2012 and the Shift of Ages

2012 and the Shift of Ages

A Guide to the End of the World

Alexander Price

Adventures Unlimited Press

Adventures Unlimited Press
One Adventure Place
Kempton, IL 60949 USA

http://www.adventuresunlimitedpress.com

ISBN 978-1-935487-01-2

Parts of Chapter 1 appeared in slightly different version in "The Rain of Loving Care: Water in Hopi Spirituality and Politics," originally published in *Water And Its Spiritual Significance*, ed. Gray Henry-Blakemore and Elena Lloyd-Sidle, Louisville, KY: Fons Vitae Press (2009). Grateful acknowledgment is made to the publishers for permission to reprint parts of that material here.

Cover design by Nemo Boko
http://r6xx.com

Inside Cover: Lotus with Naksibendi Seal. Adaptation of an original photograph © 2007 Hinduism Today, licensed under Creative Commons License.

All images, where not otherwise attributed, are from the public domain.

In the lover's heart is a lute
Which plays the melody of longing.

You say he looks crazy -
That's only because your ears are not tuned
　　　to the music by which he dances.

　　　　　　　　　　　　– *Rumi*

Contents

List of Illustrations

List of Tables

Acknowledgments

Thanks are due first and foremost to the near and extended family members whose outpouring of love and support made this book possible: Patricia and Nicholas Riley, Ashley and Aaron Severance, Larisa Odins-Lucas, John Metz. It's been a long journey to bring this book to fruition, but they never stopped believing in me. Seamus, Ian and Teagan Severance, Ayla Odins and Velika Odins-Lucas all generously shared their homes and hearts with me.

Prentice Petrino and Angel Mendez gave me the *shaktipat* I needed to get here, and continue to serve as constant beacons of hope and inspiration.

Shaykh Abdul Kerim opened every door for me, here and hereafter. If any wisdom has made it into these pages, it's from the inspiration he sent to my heart. I offer my deepest, heartfelt gratitude to them all.

Alex Price
October, 2009

I

1

The Hopi Way

The indigenous Hopi people of present-day northeastern Arizona say that humans inhabited three previous worlds before migrating to the present Fourth World. These were at first paradisiacal places, they say, but the people fell over time into harmful lifestyles and were eventually destroyed as a consequence of their choices. The story serves as a warning that if we repeat the same mistakes, we will suffer the same consequences.

As many readers may already know, December 21, 2012 is the end date of the Mayan Long Count calendar. What is less-frequently known is the close connection between the ancient Mesoamerican people and the Hopis. Both cultures descended from a common ancestor in the American Southwest, and lived in close contact with one another in the centuries prior to the fall of the Aztec Empire. The Hopis have long claimed that the Aztecs were originally a migrating clan of Hopis who settled in the lush Valley of

Mexico and did not complete the spiritual pilgrimage they were assigned by the Creator; they eventually fell into corrupt ways as they had been warned would happen, and this was the "karmic" cause of their destruction at the hands of the Conquistadors.

Archaeologists believe that the indigenous American people arrived on the North American continent by way of the Bering Strait sometime around or before 11,000 BCE.[1] The Native people themselves insist that they did not come to their land from the North or East but emerged into it directly from the underworld. The Hopis locate their Place of Emergence in the basin of the Grand Canyon, about a hundred miles west of the present-day Hopi Reservation.

Upon their emergence, they say, they were met by the guardian spirit of the land, Maasaw, who told them that before they could settle, they had to migrate throughout the land – north, south, east and west – following a spiral-shaped migration pattern across the face of the Earth before returning to reunite at the symbolic Center of the Universe. He warned them not to stay too long in the comfortable areas they would find, but to remember their obligation and continue migrating until they found the place he would show to them.

The Hopis met Maasaw again, after many centuries, in the Four Corners region of the American Southwest. One Hopi spokesman relates:

> They looked around, and [said], "Why this... we came from a better place. We had nice beautiful mountains, we had a lot of rivers, we had a lot of game and all that. But this is a desolate, God-forsaken country. Why here?"

Maasaw replied:

"The reason why you are here is because this is... a most safe place, there's going to be no more things that you have to experience. No more floodings, no more earthquakes, no more fires, nothing like that is going to happen. Because now you can be so close to me, so close to spiritual being. Then you will not forget. You're going to be so humble, that you're not going to forget that I'm there." And this is the reason why he chose it... The severity of the intense desolate weather conditions, lack of any pristine value or mineral commodity or the elements, and finally this place was situated in the middle of the "plaza," symbolic of a center of the Universe.[2]

Hopi religion is structured around the agricultural cycle, with seasonal ceremonies that ensure the fertility of the fields and sufficiency of rain. To the Hopis, there is a literal causal relationship between their ceremonies and the proper functioning of the natural world. If the ceremonies are not performed at the right time, by duly authorized people, they say, the planet will lose its balance, the entire ecosystem will collapse, and the world will be plunged into chaos. Their ceremonies, therefore, are a vital element of nature: along with the prayers and practices of religious people around the world, they keep the world in balance and ensure the safety and sustenance of all creatures everywhere.

The Hopis were among the last of the indigenous North American people to be affected by European immigration. Their contact with Conquistadors and Catholic missionaries

began in 1540, two decades after the fall of the Aztec Empire, as the Spanish continued north in search of the fabled El Dorado, City of Gold. But since the Hopis occupied an uninviting land and were apparently not in possession of any desirable natural resources – like gold lakes or streets of gold – they were more or less left to themselves through the 1850s (with the notable exception of Catholic missionary efforts).[3] In the mid-19th century, a wave of settlers was traveling west across America: like their predecessors, in search of gold. Sparked partly by curiosity for the Hopis' exotic Snake Dance – a remnant of the very ancient Mesoamerican cult of the Plumed Serpent – ethnographers and tourists developed a keen interest in them. The Hopis were increasingly confronted with demands by the new U.S. government for changes in their traditional way of life, such as the mandatory attendance of children in Euro-American schools, and the establishment of a democratic Tribal Council. Internal disagreements over whether to comply or resist led to a split among the Hopis in 1906, with the dissenting party departing from their ancestral home at Old Oraibi to found the village of Hotevilla a few miles north on Third Mesa.

The Hotevilla Traditionalist Elders viewed their village as a symbolic Center of the Universe, and a microcosm of the world. This is one of the reasons they saw their ceremonies as so important: they dramatize processes that happen throughout nature, and have a symbiotic affect on each other through sympathetic correspondence. The proper performance of the ceremonies and religious dances ensure the proper functioning of the world – which, at the local level, is undoubtedly true. They saw the events that took place there as a reflection of the situation in the wider world. It is vital,

they said, that the spiritual center of their village not die, for the North American land cannot live without its heart.

At first the residents of Hotevilla staunchly resisted attempts to install modern utilities such as water and power lines, which they felt would make them dependent on the government, rather than the Creator, for their survival. When the government proceeded to install utilities against the residents' wishes, the people repeatedly pulled the lines out of the ground at night so that construction would have to be abandoned. Eventually, however, the lines came in anyways.

The Hopis pride themselves on being a gentle, humble people: the word *Hopi*, in their language, means "peaceful." They were easily overpowered by the White Brother's "Guns, Germs and Steel," but their endurance in the face of insurmountable opposition is a testament to the power of their faith. One by one, the Traditionalist leaders aged and passed away: Dan Katchongva, Titus Qomayumptewa, David Monongye, Dan Evehema, Thomas Banyacya, and many other friends and supporters, known and unknown. Today, only one Hotevilla Traditionalist remains. Although he is now in his late eighties, Martin Gashweseoma still gets up every morning at 4 A.M. to perform the traditional prayers. He still gets his water from the spring; his is one of the last homes in Hotevilla without running water, without electricity.

I first met Grandfather Martin in the fall of 2003. My boyfriend at the time, documentary filmmaker Scott Peehl, shared my interest in Native American spirituality, so we arranged to visit the Hopi Reservation and meet Martin's

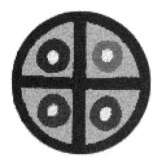

Fig. 1. *"The shield symbol with its four circles in four quadrants means: 'Together with all nations we protect both land and life, and hold the world in balance.'"* From the *Hotevilla Traditionalist newsletter* Techqua Ikachi.

son-in-law and daughter. We arrived on a sunny afternoon in Hotevilla, a small village perched on the edge of Third Mesa, jutting out over the desert plane. Its unpaved streets wound around the traditional adobe houses scattered about the village, and the desert far below stretched out to the horizon. Martin's daughter led us through the dusty streets to the peeling, sky-blue screen door of her father's adobe home.

We entered, and as our eyes adjusted to the darkened interior, we found ourselves standing in a kitchen before an ancient-looking couple, sitting at the table taking their lunch. The two of them formed a startling image: I had never seen anyone who looked so *ancient*, and was quite taken aback. The grandmother's eyes were completely covered over in white cataracts, and her skin was so deeply wrinkled it looked like the cracked desert.

Grandfather Martin waved to the two chairs at the

table before them, and his daughter let herself out the door wordlessly as we sat down.

For lunch, the elderly couple was sharing a cold can of Chicken Noodle soup. Martin stood and slowly shuffled over to a nearby cabinet to retrieve a pair of bowls and spoons, which he placed before us. He lifted the beat-up pot of soup in his shaking hands, leaned forward and deposited a teaspoonful of soup in each of our bowls. I felt a stab of shame, and a wash of gratitude for the humble meal they were sharing with us.

After eating in silence, the blind old grandmother heaved herself up onto a walker, which she used to slowly make her way around to a couch behind us. She remained sitting in the same spot for the remainder of our visit – silent, unmoving, a pillar of patience.

Scott and I helped clear the plates to a nearby sink, where I noticed there was no running water. I had expected this from what we'd read about the history of the village, but it was one thing to read about it and another thing to see it. I knew there was also no electricity, no plumbing.

Scott and I returned to our seats as Martin disappeared into a cluttered room in the back, behind a curtain. He re-emerged a moment later carrying a heavy backpack full of papers. He set his bag down on a chair, rifled through it and produced a stack of worn, dog-eared papers, which he placed on the table before us. The document looked like a photocopy of a Mayan scroll, covered in hieroglyphics.

Grandfather Martin began his presentation.

"This mountain," he began, pointing to the first glyph. "Hopi... Man is... boat getting onward like that, see..."

He had a thick accent and spoke rudimentary English.

His speech was obscured by the absence of teeth and the shaking voice of advanced age. It required an enormous amount of concentration and effort, but I eventually felt I was following him. He could tell I was struggling, and paused frequently to make sure I understood.

The hieroglyphic scroll, Grandfather Martin explained, told the story of mankind's journey to the present world from the previous one. Throughout the text, there was a line of footsteps indicating mankind's path from the previous world and through the present one, with forks in the road representing choices that faced us as we journeyed onward through history. One of these paths – the way of living in harmony with one another and the environment – led to a sustainable future. Grandfather Martin indicated that this was not the path we had taken.

When we first emerged to the present world, he explained, there were two brothers who parted ways: the younger brother was the Red Brother, the Native American people, who remained in the Americas while the older White Brother traveled east toward the rising sun. When the White Brother arrived at his destination, he was supposed to place his forehead on the ground, claiming the earth for the Creator, and then return at the end of the world cycle to rejoin his younger brother at the Center of the Universe. If he had remained true to his religious duties, when he returned he would bring advanced technological knowledge and have much to teach the younger brother about how to live more comfortably and happily in the world; but if he had left the proper way of his religion, he would return bringing destruction, disease and death, enslaving his younger brother and bringing calamity upon him.

The Spanish Conquistadors, when they arrived in the Americas, were not practicing their religion in the right way, Martin said. They did not live according to Christ's teachings of love and nonaggression. This obviously had disastrous consequences for the Native American people, but was further a very bad sign for the fate of this world: it indicated that the White Brother had left the right path and entered into a way that was leading to world destruction.

We were all instructed how to make our spiritual migrations through the world when we first arrived here, he said, and we were warned not to settle permanently in any of the comfortable places we would find, but to remember our duty and complete the spiral migration path back to the Center of the Universe. The Aztecs, Grandfather Martin explained, had not completed their journey, but settled in the comfortable environment of present-day Mexico and eventually returned to the wrong ways of living that had been the cause for the destruction of previous worlds. And so, history repeated itself. It had done so for the Aztecs and now, Grandfather Martin claimed, it was in the process of doing so for the rest of the world too.

Needless to say, this was a lot to take in. Unfortunately, Scott and I didn't have much time to spend with Martin on our first visit. After a few hours we had to part ways, awed and overwhelmed by the encounter but still with only part of the story.

I returned alone to the Hopi Reservation in 2006, with a full week set aside to talk to Grandfather Martin. Much had changed in this brief time. I'd moved to a Sufi *dergah* in upstate New York, where I was helping our community

open a religious center in the Catskill Mountains. Martin's wife, whose appearance had struck me so powerfully on the first visit, was no longer with him: she had passed on.

On this second visit, Grandfather Martin showed me a series of religious items, books and artwork that were all relevant to Hopi religion and prophecies. One was a sacred rattle with the spiral-shaped migration pattern on it. Another was a replica of the Fire Clan Tablet, one of several sacred stone tablets the Hopis say were given to them in antiquity by the Creator ("Like Moses on the mountain," Martin explained. "Every culture, they have that.") Some of these items will be shown and described throughout the rest of this book.

2

Migrations of the Aztecs

Both the Hopi and Nahuatl (Aztec) languages belong to the Uto-Aztecan language family, which is believed to have emerged from the southern half of present-day California, perhaps two thousand years ago.[4] The hypothetical Proto-Uto-Aztecan which came before that is believed to have developed much earlier, in central Mesoamerica. Both the Hopis and Aztecs descended from a common ancestor, most likely the ancient Puebloans of the American Southwest. More recently, in the time of the Aztec Empire (14th – 16th centuries CE), there was a "constant communication [and] interaction between the population south of the current Mexican - U.S. border and north [of it],"[5] which included the exchange of religious beliefs and practices.[6] Thus the Hopis and Aztecs probably had, at one point, a common cultural background, but more recently both of them were heavily influenced by the religion that had developed in Mesoamerica from the 1st through the 14th centuries CE.

Ancient Mesoamerica had a long history of succeeding political and cultural centers, beginning with the Olmec civilization that emerged in the 17th to 15th centuries BCE, and ending with the fall of the Aztec Empire in 1521 CE.[7] The Mayan civilization, which reached its height in the early 8th century CE, occupied the area from present-day Chiapas and Guatemala in the south to the Yucatan Peninsula in the north. The Mayan civilization began to decline in the 9th century, and collapsed in the early 10th century CE. The indigenous Mayan people, however, continue to occupy the area to this day.

The Mayans were succeeded by the Toltecs, and the Toltecs, in turn, passed on much of their cultural heritage to the final Mesoamerican empire, that of the Aztecs.

The Aztecs were a migrating tribe who arrived at Lake Texcoco in the Valley of Mexico in the 14th century CE, and rose to power in the early 15th century. The name *Azteca* referred to a person from *Aztlan*, the "Place of Wings" or "Place of Herons," their mythical place of origin; but in the course of their migrations, the Aztecs received from their deity the new name *Mexica*; hence, the name of their capitol city and the present-day country.

The ancient Aztecs, like the Hopis, believed that the world had been created and destroyed several times before. The *Legend of the Suns*, preserved in the Codex Chimalpopoca, tells how each of the previous worlds ended. The people who lived under the First Sun were eaten by jaguars. The people who lived under the Second Sun were giants; they were blown away and destroyed by the wind. The third human race was destroyed by a rain of fire, and the fourth was destroyed by a flood that covered

14

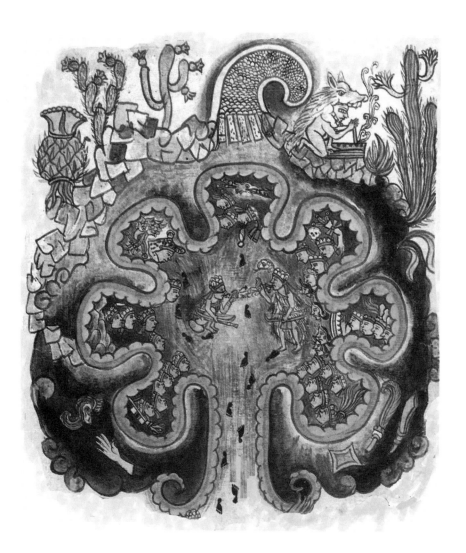

Fig. 2. *Chicomoztoc, the Place of Emergence. From the*
Historia Tolteca-Chichimeca, *16th century CE.*

the mountains for fifty-two years. Then the earth and sky were created a fifth time. The *Legend* says:

> This sun is named 4 Movement. We who live today [have] this one, it's our sun, though what's here is [merely] its signification, because the sun [itself] fell into the fire, the spirit oven, at Teotihuacan.
>
> It's the same as the sun of Topiltzin, Quetzalcoatl of Tollan [Tula].[8]

The Aztec Place of Emergence was called *Chicomostoc,* the "Place of the Seven Caves." In a well-known depiction of Chicomostoc (Fig. 2), it appears to be a womb-like enclosure with the Seven Caves opening into the Place of Emergence. According to legend, seven tribes originally joined together to become the Aztecs. Since the Nahuatl word for "cave" is often used metaphorically to mean "womb," some historians believe that the seven caves of Chicomostoc refer poetically to the seven *wombs* from which the seven tribes emerged.

The hieroglyphic codex Grandfather Martin showed to Scott and me on our visit to the Hopi Reservation was the *Tira de la Peregrinacion,* also known as the Boturini Codex or *Migration Scroll.* It is an early 16th century codex that tells the story of the Aztecs' emergence into the present world and their migration to their promised land in the Valley of Mexico. It is not a "book" in the conventional sense, but rather is one long, continuous scroll that begins on the left and proceeds toward the right in a continuous sequence. The glyphs are not words but visual cues for a narrator who would have used the text as a visual aid for an oral performance of the story.

On a recent visit to the Museo Nacional de Antropologia in Mexico City, where the codex is now located, I was able to find an archaeological magazine that offered a full reading of the scroll by a Professor of Nahuatl Literature at the Universidad Nacional Autonoma de Mexico. I thought it was important to contrast Grandfather Martin's Hopi reading against an academic interpretation of the scroll as scholars believe it was read by the Aztecs.

In the following pages, I'll present a brief reading of the opening and concluding panels of the *Migration Scroll*, not otherwise available in English. The reading is based on the interpretation of Patrick Johansson K. from a special edition of *Arqueologia Mexicana*.[9]

Tira de la Peregrinacion

The text begins with Aztlan, to the left, depicted as an island in the middle of water. There is a temple in the middle of the island with four levels and seven steps. Below the temple are a male and a female figure – the female bears a glyph that identifies her as Chimalman, the mother of Quetzalcoatl. The anonymous male figure may be Mixcoatl, Quetzalcoatl's father. The bundle on the top of the temple is a water/fire symbol, which is the glyph used of the Aztecs in the scroll, and perhaps here suggests a mystical union of water and fire. Above the temple are six houses. To the right of the island is a man in a canoe, whose hair and adornments identify him as a priest. This alludes to a tradition that the Aztec priests visited Mount Colhuacan four times before the exodus of the people from Aztlan (notice the four footprints between the canoe and the mountain). The glyph over the footprints gives the date

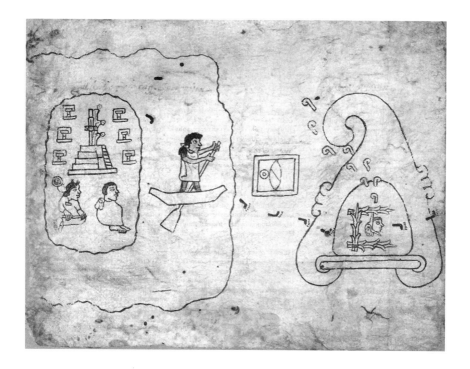

1 Flint, the traditional year for the exodus from Aztlan.

According to Professor Johansson, the accumulated symbolism of this first panel hints at insemination and the conception of a child. The name of the mountain with the cave in it, to the right side of the panel, is *Colhuacan*, which means "grandparents" – that is, the mountain of the ancestors. The cave is *Quinehuayan Oztotl*, "The Cave of Imminent Departure" (= Chicomoztoc). There is a deity (Tetzauhteotl / Huitzilopochtli) in the cave, emerging from the beak of a hummingbird. The spiral figures that rise up from the cave are used throughout the codex to indicate speech. Here they are related phonetically to the name of the cave (*ehua* = "rise").

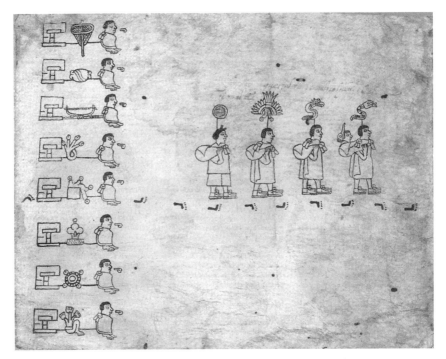

The second panel shows eight neighborhoods proceeding from the cave, which are connected to the previous panel by the footstep on the far left. Each neighborhood has its chief seated before it. From bottom to top, they are the Huexotzincas, Chalcos, Xochimilcas, Aztecs, Malinalcas, Chichimecas, Tepanecas, and Malatzincas. Proceeding forward from the Aztec neighborhood are four figures who carry sacred bundles and wear traditional Toltec headdresses. The figure in front, Tezcacoatl, "Serpent King," carries the deity Tetzauhteotl in his bundle. The first three figures are male (Tezcacoatl, Cuauhcoatl, Apanecatl) and the last is female, Chimalman.

In the third panel, the migrating tribes sit down to share a meal under a tree. The tree has an altar with the deity

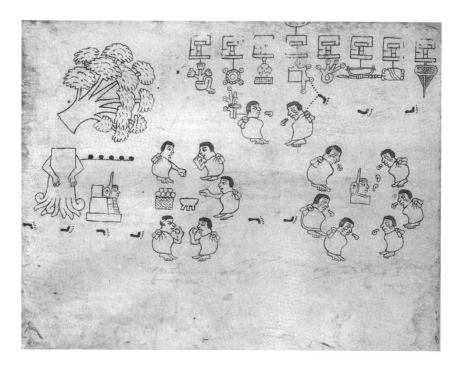

in front of it. The people have a basket of corn and are circled around a mortar, sharing a meal. Suddenly the tree beneath which they are sitting breaks in half. This is taken as a sign that the Aztecs must separate from the other neighborhoods.

To the right, the same group of people who were eating together is now gathered around the deity, who is speaking; they are crying and are also speaking.

The eight neighborhoods that were shown vertically on the left side of the previous panel are now shown in a horizontal line across the top. An Aztec priest is speaking with a person from the Aztec neighborhood who is crying. Presumably the priest has just reported the order to separate. The footsteps lead this figure away from the other neighborhoods.

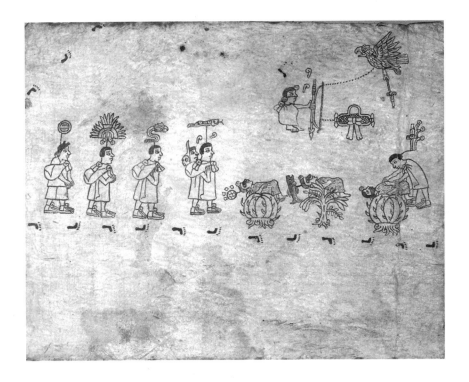

In the next panel, the four bearers of the sacred bundles continue walking. The deity carried by the leader is now speaking. They encounter three Mimixcoas, and on the order of Tetzauhteotl perform the first human sacrifice. Afterwards the deity tells them that from this point forward they will no longer be called *Aztecas* but will be known as the *Mexicas*. The deity, in the scene above this, also gives them the arrow, bow and net for hunting; the bird flying overhead has been pierced by the hunter's arrow.

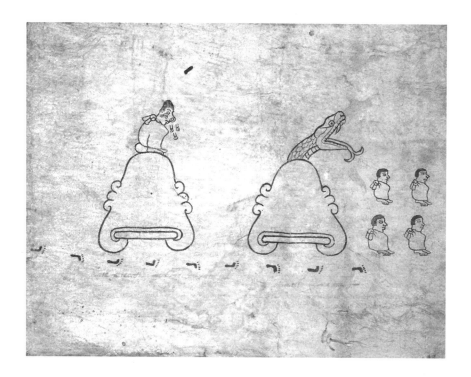

The fifth panel depicts two places where the Mexica settled, Cuexteca Ichocayan, "The Place of the Weeping Huasteco," and Mount Coatepec, "Serpent Hill." The group of four figures on the right is used throughout the codex to indicate a settlement. Coatepec is also known as the place where Tetzauhteotl was born.

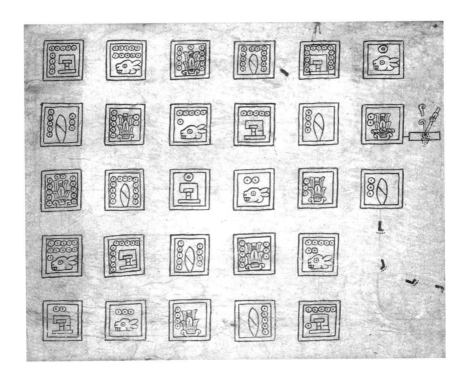

The sixth panel, like the ones that follow it, gives the dates the Mexica migrated and the places where they settled. The twenty-eight square glyphs in this panel are dates, and have a line connecting them in narrative progression. Next to the second-to-last glyph is the name of the place they settled in that year, and the last date is the year they set out again.

The next dozen panels or so will give a long series of similar dates and places, for example: "9 Flint, 10 House, 11 Rabbit, 12 Sugar Cane. In this year Sugar Cane the Mexicas resided 5 years in Tlemaco." And later, "7 House, 8 Rabbit, 9 Sugar Cane, 10 Flint, 11 House, 12 Rabbit, 13 Sugar Cane. The year 13 Sugar Cane the Mexicas stayed eight years in Tolpetlac." I am not reproducing those here because they

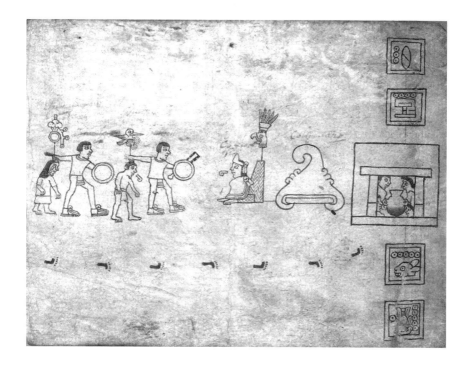

are not particularly interesting in the present context.

The Mexicas engaged in conflicts along the way, and in Colhuacan they were defeated. In the above panel (twentieth in the series) the Mexica leader Huitzilihuitl and his daughter are shown being brought before King Coxcoxtli. To the far right, the Mexicas are shown imprisoned in Colhuacan.

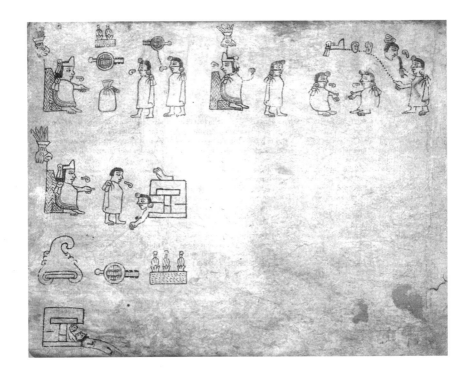

The next-to-last panel is read from the bottom to the top.

1. They went to procreate in Contitlan.

2. Then the Colhuas went to war with the Xochimilcas.

3. In danger of defeat, the king proposed utilizing the Mexica warriors, who were his prisoners.

4. The king negotiated with the Mexicas to fight the Xochimilcas for him in exchange for their freedom. They must bring him back a bag with 8,000 ears to prove that they have killed this many of his enemies. Directly to the right of that, they ask him for weapons and he refuses to supply them. Next, the Mexicas are sitting and discussing whether they will

No. 48.—A very fine Azteck Manuscript, on Maguey, in 21 folds, or leaves, on which are depicted the migrations of that extraordinary people; it is considered in Mexico as the most perfect and valuable one of the kind extant.

bring back ears or whether they should cut off noses instead, since that way the Colhuas can't argue how many enemies they really killed. They decide to go with noses.

In the final panel they are shown going off to war.

Here the story breaks off. It has been speculated that the scribe who was writing the scroll was interrupted by the arriving Conquistadors, and that is why the codex was never finished. As we know, however, the Mexicas were successful in winning their freedom, and went on to continue their migrations and eventually settle at Lake Texcoco.

* * *

One of the things I find most jarring about this story is the casual way the Aztecs take on the practice of human sacrifice. One moment they are a migrating community, fresh from the womb of the Earth at the dawn of time, and in the next scene they happen upon strangers and unhesitatingly sacrifice them over cacti. I have to wonder if this may not have been the "wrong way" Grandfather Martin says was the karmic cause for the Aztecs' downfall.

The practice of human sacrifice was intimately connected with the Aztec culture of war. A large number of ritual sacrifices were supplied from prisoners of war, and sometimes wars were even initiated specifically for the purpose of gathering sacrificial victims. When Aztec citizens were sacrificed, it was often elite warriors who laid their lives upon the altar, or else small children were used, whose tears of mortal terror were believed to bring rain through a brutal form of sympathetic magic.

The legitimacy of the practice of human sacrifice was a central point in one of the most widespread and ancient myths of Mesoamerica: that of the priest-king Topiltzin Quetzalcoatl. Scholars believe this pacifist ruler was a historical king who lived in the 10th century CE.[10] There are a large number of elaborate and conflicting accounts of his life and deeds; I will present here a brief retelling of the tale based primarily on the *Annals of Cuauhtitlan,* preserved in the Codex Chimalpopoca, with supplementary details drawn from the comparative study of H.B. Nicholson.[11]

Topiltzin Quetzalcoatl

When the Fifth Sun was created at Teotihuacan, it's said, two groups emerged and went separate ways. The Chichimeca stayed at Teotihuacan, while the other group migrated and founded the city of Tula, where they rapidly developed an advanced civilization. There they chose their first king, Totepeuh, who reigned for fifty-six years. Totepeuh was assassinated by his brother-in-law Atecpanecatl, who usurped the kingship.

Totepeuh had left behind a son, Topiltzin. When Topiltzin was nine years old, he learned of his father's murder, and went and gathered his father's bones and reburied them in a funerary temple. At the age of twenty-seven, he traveled and built a "house of fasting," and then when he was thirty his uncle-in-law Atecpanecatl died and the people of Tula came and found Topiltzin to make him their ruler and Head Priest (*quetzalcoatl*). Thus he became Topiltzin Quetzalcoatl, King and High Priest of Tula.

Topiltzin Quetzalcoatl was a devout and pious leader whose word commanded respect as far as the coastland. He prayed, did penance and fasted continuously, and would go down to the river to make ritual ablutions every night at midnight. Many people followed his example, and their practices of penitence and fasting grew into a religious movement. Under Quetzalcoatl's rule, the people prospered and enjoyed an abundance of food and wealth. Quetzalcoatl built many sacred houses, and in his religious offerings he would sacrifice only serpents, birds and butterflies.

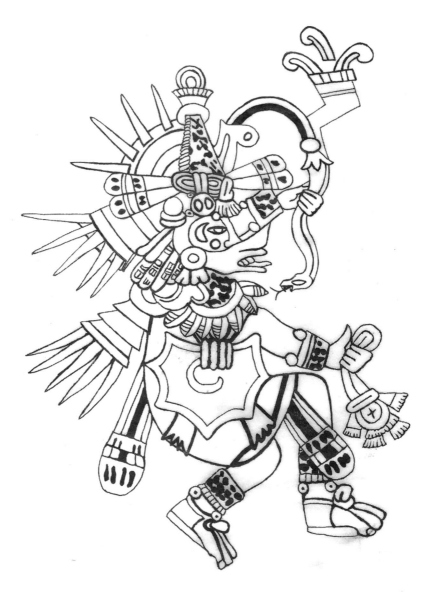

Fig. 3. *Topiltzin Quetzalcoatl. Drawing by S. Larisa-Odins Lucas, after an original at the Museo Nacional de Antropologia in Mexico City, Mexico.*

After many years of peace and prosperity, a rival cult, under the patronage of the war-god Tezcatlipoca, began pressuring Quetzalcoatl to offer human sacrifices. He refused, being strongly opposed to the practice and having a great love for his people. The pressure escalated to the point of persecution. Finally, following the advice of his deity, Quetzalcoatl decided to leave Tula.

All of the craftspeople and many citizens chose to leave with him, because of their great love for their king. When they were leaving, Quetzalcoatl buried all of the treasures he had accumulated in the mountains and canyons of the surrounding area. He and his followers migrated for a long time, stopping at many places and founding villages as they proceeded toward the coast. When they arrived at the shore, Quetzalcoatl ordered a raft of serpents to be made, and then he boarded it and sailed off toward Tlapallan, in the east. The old people among his followers maintained that he would return one day. This belief persisted up to the arrival of the Conquistadors.

The conventional account of the conquest of the Aztec Empire, partly fabricated by the Spanish, has come to be "held in suspicion by specialists in Aztec culture."[12] It's unclear to what degree Motecuhzoma Xocoyotzin (Montezuma II) and his court truly believed Hernan Cortes to be the returning god-king Quetzalcoatl. The Franciscan Friar, Fray Bernardino de Sahagun, related that even in his time (ca. 1550 – 1570 CE), after the Mexica had been thoroughly divested of any romantic illusions about the Spaniards, they still maintained the belief that Quetzalcoatl would return one day.[13]

3

Mayan Timekeeping

During the time between their settlement in the Valley of Mexico and their rise to power, "the Aztecs [took] on much of the culture that was the heritage of all the nations of the Valley from their Toltec predecessors."[14] The Calendar Round was one example of a technology that was shared throughout ancient Mexico; it "was present among all the Mesoamericans, including the Maya, and is presumably of very great age."[15]

The earliest recorded use of the Long Count calendar is believed to correspond to the date 7 December 36 BCE.[16] This places the calendar's origins within the period of the earliest Mesoamerican civilization, that of the Olmecs.

There are several known calendars that were used by the Mesoamericans to calculate time. One was the fifty-two year Calendar Round, which was adequate for describing events that happened within most people's lifetimes. The Calendar Round consisted of a 260-day calendar (*Tzolk'in*), which combined with a 365-day

calendar (*Haab*) to produce a cycle that repeated every fifty-two years. This particular length for the calendar was utilized, according to contemporary Maya, because it corresponds to the fifty-two-year cycle in which the Pleiades star cluster reappears at the same spot on the horizon.[17]

The Long Count Calendar is what is usually meant when we speak of the *Mayan Calendar*. This was based on a 360-day period called the *tun*, and was capable of describing dates at a great distance. Michael Coe, an Emeritus professor of Archaeology at Yale, describes the cycles in this calendar as follows:

> 20 k'ins = 1 winal / 20 days
> 18 winals = 1 tun / 360 days
> 20 tuns = 1 k'atun / 7,200 days
> 20 k'atuns = 1 bak'tun / 144,000 days[18]

1 k'atun of 7,200 days is roughly equivalent to twenty years; 1 bak'tun is just under 400 years. 13 bak'tuns (1,872,000 days / abt. 5,125 years) constitute one Great Cycle or "Sun." Five Suns, in turn, constitute one Grand Cycle, 25,627 years, and this corresponds to one cycle of the precession of the equinoxes.

According to contemporary Mayan Daykeeper Hunbatz Men, the purpose behind the Mayan 26,000-year calendar is not to track the precession of the equinoxes, but rather is connected, like the Calendar Round, with the Pleiades.

"The calendar of twenty-six thousand years is the calendar of the Pleiades," he explains. "For the Mayas know we belong to these stars. We are here in our solar system.

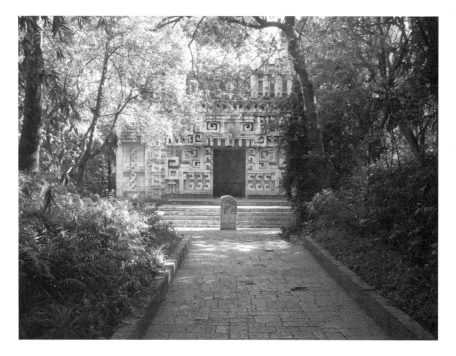

Fig. 4. *Reconstructed Mayan building at the Museo Nacional de Antropologia, Mexico City, Mexico. Photograph by Alexander Price.*

The center of the Pleiades is there. Every twenty-six thousand years, we complete one cycle around the Pleiades."[19]

 This Mayan Pleiadian calendar is called *Tzek'eb*.[20] As a Daykeeper, Men was educated by his uncle in the sacred timekeeping tradition of the Maya, and relates that there are not five Mayan calendars (the number, he says, known to archaeologists) but a full twenty calendars used by the Maya to keep track of cycles in nature. A disciple of Men and his community of Elders, Aluna Joy Yaxkin, has provided a list of the twenty calendars from her notes taken during a visit

Table 1
The Twenty Mayan Calendars

1.	Ixim Tun	130 days.	Agricultural.
2.	Mom Tun	180 days	Related to insects.
3.	Tzolk'in	260 days	
4.	Tun	360 days	
5.	Tz'otz Tun	364 days	Bat cycle.
6.	Ik Tun	364 days	Lunar.
7.	Haab'	365 days	Solar.
8.	Kiejeb	400 days	Prophetic.
9.	Muchuchu Mil	52 years	New Fire
10.	Chol Tun	260 years	Macrocosmic.
11.	Ku Tun	520 years	Religious use.
12.	Tiku Tun*	1144 years	
13.	Ajau Tun	312 years.	Prophetic.
14.	Ekomal Tun	520 years	Prophetic.
15.	Ox Lajuj Baktun	5200 years	Long Count
16.	Wach Wou	Secret.	
17.	Ox Wou	Secret.	
18.	Win Wou	Secret.	
19.	Nawual Wou	Secret.	
20.	Nimk'ku	Secret.	

* The Tiku Tun calendar of 1,144 years is composed of two parts: a 468-year "Cycle of Light" called Belejeb Bolon Tiku (composed of 9 cycles of 52 years) and a 676-year "Cycle of Darkness" called Oxalajuj Tiku (13 cycles of 52 years).

Source: Aluna Joy Yaxkin[21]

to Yucatan in 1998 (Table 1).

According to Daykeeper Gerardo Barrios Kaanek', a member of Men's community of Elders, the sacred traditions of ancient Mesoamerica were not as thoroughly obliterated as the Spaniards and later historians were led to believe.

> In the Mayan world we were fortunate that the prophecies let us know of the coming of the Conquistadors of Europe. This allowed the Mayans to prepare for this invasion. They did a lot of work before the Spaniards came to Latin America. Part of that work was to create secret libraries to keep the codices. The great elders were transferred and migrated to other areas that were inaccessible... Even though there were many warriors in the Mayan groups, the large Mayan councils discussed and decided that the confrontation must be minimal to prevent the extinction of the Mayan people and devastation of the Mayan culture. The Mayan spirituality has been going on since the beginning of time. Thanks to the great prophecies, and the advice of the elders, the prophecies were fulfilled, and towns saved. We were most fortunate that the knowledge of the Mayan Cosmology was preserved, and this knowledge is very much alive within the Mayans today as a result of the elders' vision.[22]

The general belief at present is that on December 21st, 2012, the Long Count calendar date will be 13.0.0.0.0, which is the end of one Great Cycle and the beginning of a new one.

The date 13.0.0.0.0 is also 0.0.0.0.0 of a new Sun. However, there is presently no way of knowing for certain how the Mayan calendar system correlates to the Gregorian calendar (the standard Western calendar in use today). According to astronomer Louis Strous, "The exact correspondence between the Long Count and modern calendars was lost when the Spanish Conquistadors destroyed many Maya documents in the 16th century. In the course of time, the beginning of the Long Count has been proposed to correspond to dates in our calendars that varied by as much as 1000 years."[23]

Contemporary Maya maintain that the "end of the world" predicted the Mayan calendars already happened – 500 years ago. They count the end of the Fifth Sun as the day Hernan Cortes set foot on the Yucatan shore in 1519. As Randall Jimenez and Richard Graeber, authors of *The Aztec Calendar Handbook*, explain:

> Some current Nahua people that had removed themselves from the European barrage have maintained the count and state that the 'colonial period' in North America was the Sixth Sun and that the present time is nearing the end of the Seventh Sun.[24]

This belief that a new cycle began with the arrival of Cortes is furthermore not a recent one. The Dominican Friar Diego Duran, writing in 1588, quoted from native histories that said:

> "In the year of the jubilee, which began on One Reed, the first year of the sixteenth cycle, there came

to this land Don Hernan Cortes, Marques del Valle."
This was written in the native records: "In the year
One Reed, at the beginning of the sixteenth cycle,
the Spaniards arrived in this land."[25]

"Cycle" here refers to a fifty-two-year cycle. Jimenez
& Graeber point out that Mayan prophecies predicted the
Fifth Sun would end in earthquake, and in 1533 "a massive
earthquake shuddered the Anahuac Valley, breaking the
basin of Lake Texcoco, causing it to partially drain. This may
have been the end of the Fifth Sun." Counting backwards
from that date places the beginning of the Fifth Sun in 687
CE, which, they say, corresponds to the exodus of the Olmecs
from Teotihuacan.

One thing seems clear: if the Mayan calendar predicts
something for 2012, it's not the Christian apocalypse. I
suspect that Euro-American people are supposed to have
our own traditions that tell us where we are coming from
and where we are going. Nonetheless, the Maya clearly view
2012 as a significant date. As Gaspar Pedro Gonzales, author
of *El Trece B'aktun*, explains:

> From the perspective of contemporary Maya, 2012
> constitutes a very important point in the history
> of humanity... Human beings do not exist by
> coincidence or by a work of chance. They are part
> of a plan to carry out a mission in this part of the
> universe. The world is still not totally finished in
> its creation and perfection; this human creature
> has a role to play in the world and its preservation.
> One could say that the life of the planet depends on
> human beings and what they do...[26]

II

4

Cosmic Cycles

Many cultures around the world preserve traditions of humanity's periodic destruction and renewal, often as part of a wider pattern of the death and rebirth of the natural world.

The ancient Greeks had a system of world-eras called the Great Year. This was divided into four Ages, usually associated with metals: the Golden Age, Silver Age, Bronze Age and Iron Age. Like the Hindu system of yugas, the Greek system of Great Years held that the world has seen much better days, enjoying a heavenly state in the distant past that contrasted sharply with the present world's hardship, corruption and brutal discord.

In his *Metamorphosis*, Ovid described the successive Ages from their idyllic beginnings down to the present:

[First] was the **Golden Age** that, without coercion, without laws, spontaneously nurtured the good and the true. There was no fear or punishment: there were no threatening words to be read, fixed in bronze, no crowd of suppliants fearing the judge's face: they lived safely without protection... Without the use of armies, people passed their lives in gentle peace and security. The earth herself also, freely, without the scars of ploughs, untouched by hoes, produced everything from herself. Contented with food that grew without cultivation, they collected mountain strawberries and the fruit of the strawberry tree, wild cherries, blackberries... Spring was eternal, and gentle breezes caressed with warm air the flowers that grew without being seeded. Then the untilled earth gave of its produce and, without needing renewal, the fields whitened with heavy ears of corn. Sometimes rivers of milk flowed, sometimes streams of nectar, and golden honey trickled from the green holm oak.

When Saturn was banished to gloomy Tartarus, and Jupiter ruled the world, then came the people of the **Age of Silver** that is inferior to gold, more valuable than yellow bronze. Jupiter shortened spring's first duration and made the year consist of four seasons, winter, summer, changeable autumn, and brief spring. Then parched air first glowed white scorched with the heat, and ice hung down frozen by the wind. Then houses were first made for shelter:

before that homes had been made in caves, and dense thickets, or under branches fastened with bark. Then seeds of corn were first buried in the long furrows, and bullocks groaned, burdened under the yoke.

Third came the people of the **Bronze Age**, with fiercer natures, readier to indulge in savage warfare, but not yet vicious. The harsh **Iron Age** was last. Immediately every kind of wickedness erupted into this age of baser natures: truth, shame and honor vanished; in their place were fraud, deceit, and trickery, violence and pernicious desires... The land that was once common to all, as the light of the sun is, and the air, was marked out, to its furthest boundaries, by wary surveyors. Not only did they demand the crops and the food the rich soil owed them, but they entered the bowels of the earth, and excavating brought up the wealth it had concealed in Stygian shade, wealth that incites men to crime. And now harmful iron appeared, and gold more harmful than iron. War came, whose struggles employ both, waving clashing arms with bloodstained hands. They lived on plunder: friend was not safe with friend, relative with relative, kindness was rare between brothers. Husbands longed for the death of their wives, wives for the death of their husbands... Piety was dead, and virgin Astraea, last of all the immortals to depart, herself abandoned the blood-drenched earth.[27]

Astraea, the Virgin, was the goddess who represented Justice. Classical authors were in agreement that, although the Iron Age is doomed to meet certain destruction in the end, a new Golden Age will follow as the cycle begins anew.

The ancient Hindus considered time itself to be an aspect of God, often speaking of Time as a deity (Skt. *kala*). In the Vishnu Purana, it is said that:

> The deity [Vishnu] as Time is without beginning, and his end is not known; and from him the revolutions of creation, continuance, and dissolution unintermittingly succeed: for when, in the latter season, the equilibrium of the qualities exists, and spirit is detached from matter, then the form of Vishnu which is Time abides.[28]

The epic *Mahabharata*, one of the core texts of Hindu religions, teaches that the world cycles through four great time periods, called *yugas*. Over vast stretches of time, universes are born, planets evolve, stars die – and eventually everything is reabsorbed into God, as one cycle ends and another begins. The four yugas of the cycle are the Satya (or Kritta) Yuga, Treta Yuga, Dwapara Yuga and Kali Yuga.

In the *Mahabharata*, the deity Hanuman describes the Yugas to Bhima, one of the book's protagonists:

> Kritta is the name of the yuga, dear one, in which dharma is eternal. [Everything is] complete and there is nothing left to be completed, in that supreme yuga. Dharmas do not decay then, nor do creatures waste away. Therefore, it is called **Kritta Yuga**, which

in time became identified with excellence. In the Kritta Yuga there are no gods, *danavas, gandharvas, yaksas, raksasas** or snakes, dear one; and no buying or selling... There was no human labor; fruits were obtained [merely] by wishing for them, and renunciation was the only dharma. During that yuga there was no disease, no weakening of the senses, no calumny, no crying, no arrogance, no slander; No quarrelling, no laziness, no hatred, no cheating, no fear, no suffering, no envy, and no selfishness. Therefore, the highest *brahman*, the supreme goal of yogis, was the soul of all beings (i.e. attainable to all); and Narayana [Krishna – *ed.*] was white then... In the Kritta Yuga, all creatures were engaged in their proper work... [The castes] used one Veda, they had one set of mantras, injunctions and modes of practice. They had different characteristics (*dharmas*), but, having the same Veda, they followed one dharma... This is called the Kritta Yuga, from which the three qualities (*gunas*) are absent.

Now learn about the **Treta**, in which the sacrificial session (*satra*) appears. Dharma is diminished by one quarter, and Acyuta (Krishna) becomes red. Men are truthful and devoted to the dharma of [ritual] acts. Then sacrifices (*yajnas*) appear, as do different kinds of dharmas and rituals (*kriyas*). In Treta, these have specific purposes; people gain rewards through rituals and charity. People in the Treta Yuga do not stray from dharma. They are devoted to austerities and to

* *kinds of supernatural beings – ed.*

giving, they follow their own dharma and perform rituals the right way.

In the **Dvapara Yuga**, dharma is lessened by half. Vishnu becomes yellow, and the Veda is divided into four parts. Some people [know] four Vedas, others three, two, or one; some don't even know the Rig (Veda)... Out of lack of knowledge of the one Veda, the Vedas become many. Due to the decline of [regard for] truth, there are now only some who abide by it. Many diseases befall those who lapse from truth. Lust and calamities occur then, caused by destiny. Greatly afflicted by them, some people practice austerities. Others perform sacrifices, wishing to obtain earthly goods or heaven. In this way, when the Dvapara arrives, creatures are destroyed because of *adharma*.

In the **Kali Yuga**, Kaunteya, only a fourth part of dharma remains. When the dark (*tamasa*) yuga arrives, Kesava (Krishna) becomes black (*krsna*). Vedic practices decline, as do dharma and the practice of sacrifice. There are natural disasters, diseases, laziness, bad qualities such as anger and the like, calamities, and mental as well as physical suffering. With the succession of yugas, dharma deteriorates; with the deterioration of dharma, the world also deteriorates. When the world is in a state of decay, the conditions that allow for its advancement are destroyed. The religious practices (dharmas) performed at the end of the yuga produce opposite results. Such is the yuga called Kali.[29]

One complete cycle, called a Mahayuga, is usually said to span 4.32 million years. However, Sri Yukteswar Giri, a well-known disciple of Mahavatar Babaji and guru of Paramahansa Yogananda (*Autobiography of a Yogi*), claimed that this is a common misconception. In his book, *The Holy Science,* Sri Yukteswar quoted the Samhita of the rishi Manu as giving the correct calculation:

> "[4,000] years, they say, is the Krita Yuga (Satya Yuga or the 'Golden Age' of the world). Its morning twilight has just as many hundreds, and its period of evening dusk is of the same length (i.e., 400 + 4000 + 400 = 4800). In the other three ages, with their morning and evening twilights, the thousands and the hundreds decrease by one (i.e., 300 + 3000 + 300 = 3600; etc.). That fourfold cycle comprising 12,000 years is called an Age of the Gods. The sum of a thousand divine ages constitutes one day of Brahma; and of the same length is its night."[30]

Sri Yukteswar explained that this correct calculation corresponds to one complete cycle of the precession of the equinoxes: after descending through the four stages, he said, the cycle does not suddenly jump up to the highest point to begin again from the top, but rather it gradually ascends back through the same four stages in reverse order. Thus one cycle has two mirror-image segments: 12,000 years descending through Satya, Treta, Dwapara and Kali yugas, and another 12,000 years ascending through Kali, Dawapara, Treta and Satya yugas, to total 24,000 years. Sri Yukteswar associated this 24,000-year period with the cycle of the precession of the equinoxes.

Since the precession of the equinoxes is such a prominent element of this discussion, it's worth taking a moment go over what it is.

Precession of the Equinoxes

Rather than being perfectly "vertical," so to speak, at a right angle to the sun, the earth's axis is tilted at about a twenty-three degree angle. Because of this tilt, we experience the cycle of the seasons, as well as the varying lengths of the days and nights throughout the year. The day in the Northern hemisphere is longest at the Summer Solstice around June 21st, and the night is longest at the Winter Solstice about December 21st. In between these two points are two days each year when the day and night are more or less equal, somewhere in the world: these are the Equinoxes, in March and September.

The map of the constellations we have in the West today was primarily developed in ancient Mesopotamia, and we inherited it by way of the Greeks. The earliest records presently available indicate that this ancient sky-map first developed along two separate lines: a rustic version employed by farmers, and a religious one employed by priests for divination. (Their divinatory practice was not yet astrology as we understand it today, as the idea of a personal horoscope did not develop until much later, in the 5th century BCE).[31] The four earliest known constellations – Taurus, Leo, Scorpio and Aquarius – contained the equinoxes and solstices around 4000 - 2800 BCE.[32] Their images of the Bull, Lion, Scorpion and Water-Bearer were all prominent elements of Mesopotamian art.[33] Keeping track of the equinoxes had practical value for

farmers, allowing them to optimally time their planting and harvesting (note that Taurus, the Bull, contains the Pleiades star cluster, which is used worldwide for coordinating the agricultural cycle). The presence of the four earliest-known constellations at the cardinal points during the time of their first appearance may indicate how and why the zodiac first developed.

In the first millennium BCE, when Greek astronomers inherited the constellations from Mesopotamia, they discovered that the recorded positions for the equinoxes did not correspond with what they observed in the sky. This was initially thought to have been an error in the original Mesopotamian calculations, but it was soon recognized that the positions of the constellations themselves had changed. This led the Greek mathematician Hipparchus, sometime in the mid-2nd century BCE, to what is generally credited as the discovery of the precession of the equinoxes.

Precession of the equinoxes refers to the approximately 26,000-year cycle in which the circle of the zodiac rotates one full turn around the earth (technically, around the celestial equator, which is the earth's equator projected onto the sky). The circle shifts approximately one degree every seventy-two years, taking just over 2,100 years to move from one of the twelve zodiac signs to the next. Around 3000 BCE, the sun on the Spring equinox was in Taurus, by 140 BCE it had shifted into Aries, and today it is moving out of Pisces and into Aquarius. The exact length of the cycle varies over time; according to astronomers, over the next 500,000 years the length of the cycle will vary between 24,820 and 26,550 years, but it is now about 25,744 years.[34]

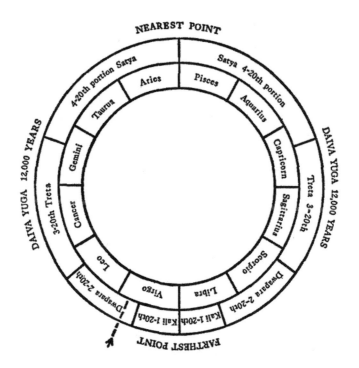

Fig. 5. *Sri Yukteswar's diagram of the zodiac as it relates to the yuga cycle. From The Holy Science by Swami Sri Yukteswar. © 1990 Self-Realization Fellowship. Used by permission.*

Fig. 5 shows a diagram from *The Holy Science,* which relates the zodiac with the Yuga cycle. The arrow on the diagram appears to indicate that we're passing from Virgo to Leo, but this is because Sri Yukteswar was using the sun's position on the Autumnal Equinox rather than the Vernal (Spring) Equinox, as Western astrologers do. To use the Spring Equinox instead, rotate the inner circle 180 degrees and the diagram works exactly the same: Virgo becomes Pisces, Leo becomes Aquarius, etc. Since *The Holy Science* was written in 1894, we are further along in the shift from Kali to Dwapara (and out of Pisces into Aquarius) than is indicated in this diagram.

5

Universal Religion

In the mid-1970's, a Hindu Guru of the 2,300-year-old Natha lineage, Satguru Sivaya Subramuniyaswami, said his inner psychic eye opened on a book from the ancient library of the deity Subramanya. In the weeks and months that followed, his disciples gathered close and transcribed while he watched the pages turn and read the text aloud. The result was a remarkable book, *Lemurian Scrolls*, which remained restricted to high-level initiates in the Saiva Siddhanta Order for the next twenty-four years. In 1997, while preparing a private printing of a few hundred copies for long-time students, Subramuniyaswami relates that the "divine thrust came to release [*Lemurian Scrolls*] freely to the world at large," and the book was published for the general public.

Lemurian Scrolls, he says, was written in two parts by disciples at ashrams in Lemuria, one part near the end of the Treta Yuga and the other in the Dvapara Yuga. The book

opens with the story of mankind's migration to Earth from the Pleiades star cluster during the Satya Yuga – a story I will summarize here.

The first humans arrived on Earth, the *Scrolls* say, in subtle etheric bodies, and used the "thick clouds of gases and healthful substances" on the planet to form physical bodies through which to express themselves. Those who were first to arrive aided the ones who arrived subsequently by making offerings to them of cut fruit, flowers and other substances, the essences of which the arriving beings used to manifest delicate physical forms. Their bodies eventually became dense enough to smell and feel, and in time they were able to eat normally like the animals that already occupied the planet. This was done in temples, where the priests would make the offerings on a pedestal, which served as a focus of concentration.

> The celestial beings would stand on the pedestal and absorb the Earth's pungent substances and with it materialize strong physical bodies. In the beginning it took a long time to bring the etheric body of a soul into physical form so he could walk off this pedestal on his own in the Earth's atmosphere. But through the thousands of years that passed, it became a very rapid process, and the entire Earth became populated with celestial beings from several of the major planets in the galaxy. Thus, the souls arrived in full force to begin a long, tedious evolutionary pattern through the three yugas to follow.[35]

Near the end of the Treta Yuga, some of these celestial beings were caught and eaten by the planet's carnivorous creatures, and in this manner they entered the evolutionary cycle of animals, being reborn afterwards with an animal nervous system and animal instincts but a divine soul. The process of becoming liberated from the animal body after that would take an extremely long time, but during the Kali Yuga, the *Scrolls* predicted, a human kingdom would begin to emerge from the animal kingdom, and at the end of the Kali Yuga the conditions would appear for many souls to become liberated, having realized the Self and thus accomplished their purpose in migrating to the planet.

* * *

Since at least the latter half of the 18th century, Western esotericists have claimed that there is a secret inner tradition that has been upheld by enlightened people in every religion from ancient times to the present. Among the proponents of this philosophy, the writings of Helena Blavatsky have had a uniquely far-reaching impact.

Madame Helena Petrovna Blavatsky (b. 1831 - d. 1891) was a daughter of Russian nobility and an intellectual heiress to the Russian Age of Enlightenment. In 1848, at the age of seventeen, the young Blavatsky fled on a stolen horse from an unhappy arranged marriage, to spend the next ten years wandering around the world, collecting esoteric wisdom from a wide assortment of gurus and masters – no doubt among many extraordinary adventures and equally extraordinary hardships. In 1873, she immigrated to New York City, where in 1875 she co-founded the Theosophical Society.

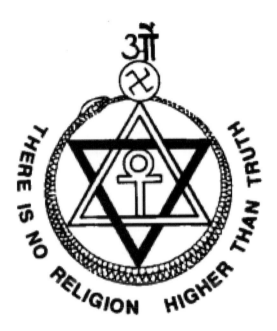

Fig. 6. *Seal of the Theosophical Society. This material was reproduced by permission of Quest Books, the imprint of the Theosophical Publishing House (www.questbooks.net).*

Now a mature Adept in her own right, Blavatsky claimed to represent a secret association of mystical Adepts who had sent her forth to correct some errors that had developed in the nascent Spiritualist movement (which, she said, they also had created).[36] An eminent Theosophist, the Countess Wachtmeister, addressing a Spiritualist audience in 1897, gave an extraordinary account of Spiritualism's origins. As quoted by Jocelyn Godwin:

A group of Atlantean Adepts, who had brought with them the traditions of that older period of time

and the knowledge of Occultism, as practiced in those early days, seeing how the world was rushing down into materialism with rapid strides, noticing how, as persons were developing their intellectual powers, the churches gradually lost their hold upon them, and so having nothing to cling to they were drifting down into materialism, the Lodge determined to stop this terrible downward course; and a spiritual influx was thrown down here into America, and then began the Rochester manifestations, these Adepts being living men, great souls from Atlantis incarnated into the bodies of North American Indians. It was they who brought forward this grand movement of Spiritualism.[37]

And to think, all this time we thought it was the dolphins.

In an article published in *The Theosophist* in 1883, Madame Blavatsky had succinctly summarized her own chronicle of human history:

During the occupation of the Earth for one period by the great tidal wave of humanity, seven great races are successively developed, their end being in every case marked by a tremendous cataclysm which changes the face of the earth in the distribution of land and water. The present race of mankind, as often stated, is the fifth race. The inhabitants of the great continent of Atlantis were the fourth race. When they were in their prime, the European continent was not in existence as we know it now,

but none the less was there free communication between Atlantis and such portions of Europe as did exist, and Egypt. The ancient Egyptians themselves were not an Atlantic colony.[38]

In the same article she affirmed that there was "an ancient connection between the central American peoples and the lost continent of Atlantis."

Annie Besant – President of the Theosophical Society after the death of Blavatsky's successor Henry Olcott – was in agreement with Countess Wachtmeister's account. Godwin quotes from a talk given by Besant in India during World War I and published in 1921; I reproduce here a slightly different selection from the same talk, which I will quote at length for different reasons.

Most of you have doubtless heard of the Brotherhood of Yucatan, in Mexico, an exceedingly remarkable group of Occultists, who came down by definite succession in Fourth Race bodies, maintaining the Fourth Race methods of occult progress... They are utilizing bodies whose nervous constitution is very much finer, is more highly organized, especially those who in the decadence of the Fourth Race went on under the special guidance of the White Lodge of the time, and took up methods which were specially intended to save the Fifth Race from the catastrophe in which a majority of the Fourth Race were overwhelmed in the great cataclysm of Atlantis. None the less, as I say, the Fourth Race remains the majority [on earth today?], and this

Occult Brotherhood of Yucatan is specially charged
with looking after them. Their methods have always
been – as were Fourth Race methods of the past
– those which dealt with the advance of mankind
through what is called now "the lower psychism";
that is, through a number of occult phenomena
connected with the physical plane and tangible,
so that, on the physical plane, proofs might be
afforded of the reality of the hidden worlds...

...[W]hen it was seen that the Fifth Race
was drifting into materialism in its most advanced
members, the scientific world, and that knowledge
was progressing much faster than the social
conscience and moral evolution, it was thought
necessary to start a movement which would appeal
to those who were materialistically-minded, and
would afford them a certain amount of proof,
tangible on the physical plane, of the reality of the
superphysical, of the unseen, though not of the
spiritual, worlds.

Hence the Spiritualist Movement. That
proceeded in the Western world by demonstrations
available to physical investigation, by knocking, by
tilting of material objects, such as tables, chairs, or
anything else that was conveniently movable. Later
on, there were voices that were made audible, and
still later what is called "materialization"...

The Yucatan Brotherhood, accustomed to
the use of that method, handed down from ancient
days, took up the guidance of this rescue movement.
Sometimes, in the early days of the Theosophical

Society, its Masters Themselves manifested in this fashion; at other times, They spoke and taught through H. P. Blavatsky...

Materialization is not so marked now as it was in the earlier days, when we find that very many of the "controls" were North American Indians. It was very characteristic of the early phases. It began in America, of course, where the available people were, so to speak, most handy, and you find a number of American Indians acting as controls of those first mediums. They were given all sorts of names, such as "Sunshine," and the like. When they materialized, they materialized in their own forms, which very often were those of children...[39]

* * *

The first question that ought immediately to arise is: if this is so, why is there no evidence of Atlantis or Lemuria's existence? Isn't the most likely explanation that they simply didn't exist?

The answer implied by Blavatsky and Rene Guenon, and articulated by the latter's followers,[40] was that the earlier cycles of humanity had not yet fully descended into material form, and thus did not *have* physical evidence of their existence to leave behind.

In any case, whatever, gross or subtle plane they understand them to have inhabited, contemporary Native American groups include the legendary continents of Atlantis and Lemuria in their mythico-historical narratives.

On my second visit to the Hopi reservation in 2006, Grandfather Martin showed me a book of maps titled *Cycles: A View of Planet Earth from 4 Million BC to 15,000 AD.*[41] It was published in South Africa in 2000, and presented a series of maps showing Earth changes from 4 million BCE up to 15,000 CE. The purpose of the maps was to show how the ancient continents of Atlantis and Lemuria were once aspects of the planet's geography. According to the maps, for millions of years – from 4 million BCE to 10,000 BCE – the small landmass of Atlantis extended off the northwestern edge of Africa, experiencing a series of cataclysms beginning around 800,000 BCE. There was an enormous spread of land from Asia down to Australia, which constituted the ancient continent of Lemuria. This began to break up sometime around 700,000 – 500,000 BCE, settling into a form that resembled its present geography sometime around 300,000 – 100,000 BCE.

Over the next millennium (after the year 2000 CE), the cartographer foresaw extensive future changes in the planet's geography. By 3000 CE, much of the eastern half of North America and the northeastern part of South America would be under water, along with a central band of Africa. Meanwhile, Lemuria would begin re-emerging from the Pacific Ocean. Some of the Americas would re-emerge around 9000 CE, and by 15,000 CE would form a single band with a large lake around where the Gulf of Mexico is now, while Africa would also have expanded and Lemuria would have re-emerged as a significant presence in the Pacific Ocean area.

Grandfather Martin showed me this book without comment, but I infer that he meant to suggest that Lemuria and Atlantis were the two previous worlds inhabited by

humans in Hopi traditional history, before we migrated to the present Fourth World.

Hunbatz Men's association of Mayan Elders is more explicit about this belief. Grandfather Kaanek' relates:

> The great Gods... made the plans to begin life in this part of the universe. When they were finished, they call[ed] upon the great builders of this project... These four builders came to this part of the universe and created the galaxies, the solar system, the beginning of life on this planet, and planned the four primary continents. These continents were called Kax Uleu, the red earth; Sak Uleu, the white earth; Akab Uleu, the black earth; and Rax Uleu, the yellow earth. In the western world, these continents are called Atlantis (the red continent), Yis (the white continent), Mu (the black continent), and Lemuria (the yellow continent). Atlantis was what the Caribbean Islands are now, beginning in Florida, making an arc and following all the way to Venezuela. Yis, was the North Pole. Mu, was south of Africa. Lemuria, was between Australia and the islands to the northeast of Australia. Each one of these continents had the seed of the four races of the universe.[42]

6

The Path of the Sun

Linguists and historians of the early 19th century believed that mankind had historically originated from a single place, with one language and one religion from which all others subsequently descended. An enormous amount of intellectual effort was directed toward the reconstruction of this primordial culture. Among the ideas that would enjoy an enduring popularity, into the early 20th century, was the notion that all religions had descended from a primitive cult of Sun worship. According to this theory, all the world's great religious traditions were really allegories for the Sun's labors through the year: his death in Fall, his residence in the underworld in Winter, and his rebirth in Spring. This death-and-rebirth of the Sun god in turn was associated with his (sexualized) powers of regeneration, as expressed particularly in the death and renewal of vegetation.

At least as early as Philo of Alexandria (ca. 40 CE), we can find an astronomical interpretation of mythology

applied to the Hebrew scriptures.[43] Philo drew a connection between the twelve signs of the zodiac and the Twelve Tribes of Israel, based on a passage from Genesis:

> [Joseph] dreamed another dream and told it to his brothers, saying, "Look, I have had another dream: And this time, the sun, the moon, and eleven stars were bowing down to me." And when he told it to his father and his brothers, his father berated him. "What," he said to him, "is this dream you have dreamed? Are we to come, I and your mother and your brothers, and bow low to you on the ground?"[44]

Joseph's father (Jacob-Israel) has taken it for granted here that he and his wife represent the Sun and Moon, while Joseph and his eleven brothers represent the stars. Famously, the blessings Israel confers on his twelve sons – patriarchs of the Twelve Tribes of Israel – at the end of Genesis (ch. 49) have compelling astrological correlates: "Simeon and Levi are a pair... Judah is a lion's whelp... Dan shall be a serpent... Archers bitterly assailed [Joseph]..."

Although astrology as a form of divination was sharply criticized in Judaism, seen as infringing upon God's sovereign power over human fate – as *signs* of God's power, the symbolism of the constellations found more acceptance. Medieval Jewish mystics, for example, held that the sky was a spiritual mirror of the terrestrial world, and that the importance of the Twelve Tribes on earth was reflected above in the twelve signs of the zodiac.[45]

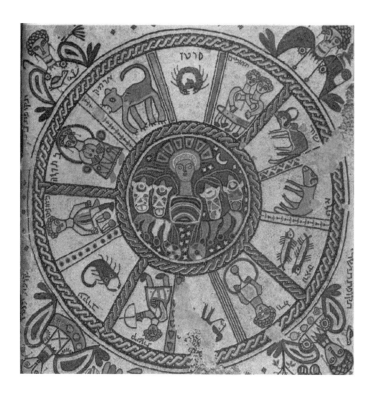

Fig. 7. *Mosaic from a synagogue at Beth Alpha showing the twelve signs of the zodiac with the Sun in the center driving his chariot. 6th century CE.*

Joscelyn Godwin relates that the idea that ancient myths were allegories for the sun's passage through the zodiac appears as early as the 5th century CE in the work of the encyclopedist and Neoplatonist philosopher Macrobius, who related the twelve signs of the zodiac to the twelve labors of Hercules. In the late 1700's, a French professor of rhetoric named Charles-Francois Dupuis revived the idea in his book *L'Origine de tous les cultes, ou Religion universelle* ("The Origin of All the Faiths, or Universal Religion"). The "central theme of Dupuis's book, and the 'origin of all religions' of its title," Godwin relates, was that "they all are to be traced to the passage of the sun through the twelve signs of the zodiac." Godwin's study, *The Theosophical Enlightenment*, is my primary source for the following history.[46]

In 1770, Godwin relates, a French mythographer named Nicholas Boulanger "suggested that the patriarch Enoch (Gen. 5:22-24), who lived 365 years and did not die, was simply the sun. With the help of fantastic etymologies, Boulanger went on to identify this figure with Noah, Hermes, and even with Saint Peter..." A subsequent book, *L'Antiquité dévoilée par ses usages,* authored by Boulanger and rewritten by the atheist philosopher Baron d'Holbach, addressed the Greek Mysteries:

> This explained the Mysteries as having taught, through impressive displays, the survival of the soul after death – a belief not generally held in the ancient world until proclaimed by Christianity. But the Orphics taught an even more esoteric doctrine: that of the past and future destructions of the world, and of the eventual death of the gods themselves.

In this respect, says Boulanger, Orphism resembled the system of the Brahmins, with their successive creations and destructions of the globe. [47]

Later, in 1822, a shoemaker named Sampson Mackey authored *The Mythological Astronomy of the Ancients Demonstrated*, followed in 1823 by a second part, *The Key of Urania, the Wards of Which Will Unlock All the Mysteries of Antiquity* (Urania being the muse of astrology in Greek myth). The essence of Mackey's unique theory, presented in rhyming verse, was that the tilt of the Earth's axis proceeds over time to such extremes that it is sometimes perpindicular to its orbit and at other times perfectly vertical. At one extreme, the world enjoys a heavenly Golden Age and there are no seasons at all, but the weather is uniformly pleasant year-round; at the other extreme, the seasons vary wildly between extraordinary heat and frost, resulting in an "Age of Horror" on the planet. Mackey's book enjoyed wide popularity, particularly because of the great age it attributed to humanity, which went far beyond the traditionally accepted date for the creation of the world in 4004 BCE.

In 1833, Godfrey Higgins published his two volume, 1,500-page opus, *Anacalypsis: An Attempt to Draw Aside the Veil of the Saitic Isis or an Inquiry into the Origin of Languages, Nations and Religions.* An excerpt from Godwin's summary follows:

> "In the beginning," all the planets revolved around the sun in the same time and the same plane. The pole of the earth coincided with the pole of the heavens, and the Arctic regions were warm... The

earliest race was of one faith, one color, and one language, and spread over the entire globe... The basic doctrines of this period, which have all survived in one form or another to the present, were the immortality of the soul, metemphsychosis, the final reabsorption of all things into the One, and the periodic renewal of worlds. An interest in the latter led the ancient sages to study astronomy and cosmic cycles, enabling them to make preparations for the all-but-universal Deluge that upset the orderly solar system and brought about the ruin of the primordial world.

There have been at least three partial deluges, caused by the earth's meeting with a comet. As a result of the last one... the length of the year, month, and precessional period all changed. Two cycles were rediscovered by the Chaldeans: that of the astrological ages of 2,160 years each, and the [cycle] of conjunctions of the sun and moon at the spring equinox... All of these numbers are commemorated by significant names and phrases in the languages where the letters have numerical equivalents. Such was the work of the "esoteric" priesthoods, while exoteric doctrines were given to the common people...

The most venerable symbol of the One has always been the visible sun, and all religions are therefore, on one level, forms of solar worship.[48]

At one point in *Anacalypsis*, Higgins had remarked that:

> M. Dupuis has demonstrated that the labours of Hercules are nothing but a history of the passage of the sun through the signs of the Zodiac; and that Hercules is the sun in Aries or the Ram, Bacchus the sun in Taurus or the Bull.[49]

And later in the same volume:

> The labours of Hercules were all astronomically explained by Mons. Dupuis in a manner which admits of no dispute. They are the history of the annual passage of the sun through the signs of the Zodiac, as may be seen on the globe, it being corrected to the proper era and latitude.[50]

Madame Blavatsky's 1877 literary debut, *Isis Unveiled*, bore some striking similarities to Higgins's *Anacalypsis*, although, according to her –

> The speculations of Dupuis, Volney, and Godfrey Higgins on the secret meaning of the cycles, or the kalpas and the yogs [yugas] of the Brahmans and Buddhists, amounted to little, as they did not have the key to the esoteric, spiritual doctrine therein contained.[51]

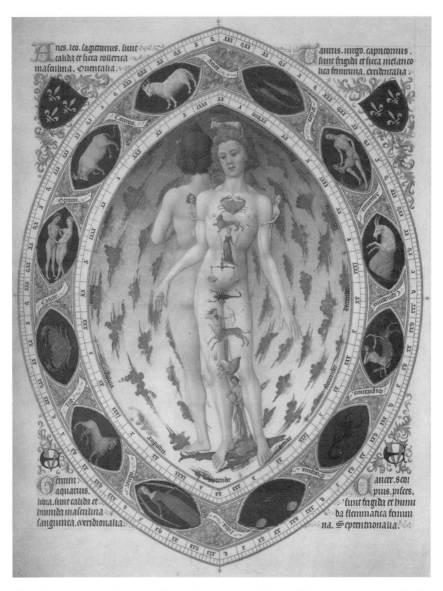

Fig. 8. *Diagram relating the twelve signs of the zodiac to the human body. From the illuminated manuscript* Les Tres Riches Heures du Duc de Berry. *15th century CE.*

As far as I know, Blavatsky did not explicitly spell out the nature of this key, but it is worth noting (though it's not surprising) that she saw the great cosmic cycles as having an inner, spiritual meaning.

A decade later, in 1888, Blavatsky commented in a footnote of an article that:

> Every act of the Jesus of the New Testament, every word attributed to him, every event related of him during the three years of the mission he is said to have accomplished, rests on the programme of the Cycle of Initiation, a cycle founded on the Precession of the Equinoxes and the Signs of the Zodiac.[52]

This pregnant passage provides a wealth of information about Blavatsky's understanding of the Sacred Science.

In *The Secret Doctrine* (also published in 1888), Blavatsky elaborated:

> The cycle of Initiation was a reproduction in miniature of that great series of cosmic changes to which astronomers have given the name of the Tropical or Sidereal Year. Just as, at the close of the Sidereal Year (25,868 years), the heavenly bodies return to the same relative positions as they occupied at its outset, so at the close of the cycle of Initiation the Inner Man has regained the pristine state of divine purity and knowledge from which he set out on his cycle of terrestrial incarnation.[53]

Later in the same book, Blavatsky discussed the great astronomical cycles and the complex way they affect the different "root races" according to their respective karmas. She claimed that this understanding can only come through Initiation, and then explained:

> The Grand Cycle includes the progress of mankind from the appearance of primordial man of etheral form. It runs through the inner cycles of his (man's) progressive evolution from the ethereal down to the semi-ethereal and purely physical: down to the redemption of man from his coat of skin and matter, after which it continues running its course downward and then upward again, to meet at the culmination of a Round, when the manvantaric "Serpent swallows its tail" and seven minor cycles are passed.[54]

It seems to me that a coherent picture of the objective of Theosophy is beginning to emerge here. (The "coats of skins" is an allusion to Genesis 3:21). It further seems that the project's essence is to be discovered in the practice of kundalini yoga.

* * *

In the preceding chapters, we saw how several ancient cosmologies were associated with the cycle of the precession of the equinoxes, and how this cycle has been seen by a number of Western esotericists as having an inner meaning that is central to the mystical journey towards enlightenment (Initiation). These mystics asserted the existence of a

perennial tradition within all the world's inspired religions, and traced their own lineage to Egypt and Mesopotamia via Greece. Their connecting link with these cultures was the esoteric doctrine of astrology.

In the next few chapters, we'll explore some key points about religion in the ancient world, and review a selection of myths from Egypt and Mesopotamia. The purpose in doing this is both to establish a context for certain images that appear in myths and in the signs of the zodiac, and to see if it is even *remotely possible* that there was something like an esoteric tradition inherited by the Greeks from the Near East. This will all lead up, in the final chapter, to an interpretation of the bull-slaying scene from the Greco-Roman Mysteries of Mithras, which I believe offers a coherent interpretation of the *prisca theoloia* claimed by the mystics.

7

The Master of Animals

Of the four earliest zodiac constellations, the animals associated with Leo and Taurus had a unique prominence in the ancient imagination. The bull and lion are powerful images that dominated mankind's earliest creative expressions and survived as central figures in religious stories until the rise of Christianity in the Roman Empire.

The wild bull was a favorite subject of prehistoric cave painters, who have provided us with mankind's first enduring efforts at visual art. The virile and mighty bull lent itself naturally as a potent symbol of raw, masculine power. The wild aurochs bull that thrived prior to the domestication of cattle was significantly larger than its contemporary survivors, standing over six feet tall at the shoulder and weighing over two tons. Surely, killing such an opponent was no simple task. Even today, bullfighting remains a dangerous occupation, with bullfighters facing up against the auroch's greatly diminished descendant. How much more of an achievement must it

have been for a prehistoric band of hunters to overcome the almost godlike power of the aurochs?

Archaeologists have been able to determine that the caverns in which cave art appears were not used as domiciles, which has led some to conclude that the caves probably provided a sacred or ritual setting, perhaps serving as mankind's first religious temples.

Anthropologists Ekkehart Malokti and Ken Gary report that: "There exists today a near-consensus of opinion among scholars that shamanism is humankind's oldest religious paradigm."[55] While the concept of *shamanism* has been criticized as being used in an often over-general and Eurocentric way, it remains valid as a term that describes a distinct cluster of practices and beliefs that can be found in primitive societies worldwide. The debate has been embedded in wider issues within the social sciences, stemming partly from Victorian-era conceptions of evolution that saw British civilization as the crowning achievement of human progress.[56] Over the past century, the academic community in general has become increasingly sensitive to cultural biases in the analysis of social phenomena, and this has greatly altered how we look at primitive communities.

One of the core elements of shamanism is the otherworldly-journey: the descent/ascent/passage to an alternate or parallel realm beyond normal human experience. The shaman claims to be able to visit the underworld where the deceased ancestors live, and to act as an intermediary between the worlds of the living and the dead. Belief in the existence of life after death itself has been speculated to have originated from the appearance of the deceased in dreams, leading early humans to the

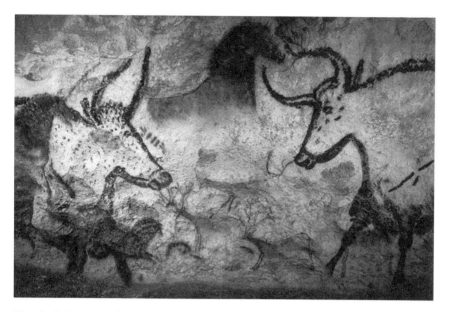

Fig. 9. *Paintings of wild aurochs bulls decorate the walls of a cave in Lascaux, France. Upper Paleolithic, ca. 18,600 BCE.*

hypothesis that the dead continue to live somewhere in a parallel spirit-realm. The grave, in a sense, is precisely where the shaman's specialized knowledge begins.

There is little evidence of how religion might first have originated. When archaeologists today discuss the evolution of religion, they tend to focus on evidence from prehistoric burial sites and artifacts such as stone arrangements and animal bones that appear to have been used in a ritualistic manner. In general, the evidence is so scarce and so ambiguous that most interpretations remain controversial. Some researchers have interpreted the discovery of bones and artifacts in a cave in France as evidence of a prehistoric bear cult. It is generally accepted that the deliberate arrangement of a body in a grave,

accompanied by offerings such as beads, food or drink, and other valuables seems to indicate belief in an afterlife.

Other recent theories about the emergence of religion have discussed cognitive developmental aspects (i.e., "At what point was the human brain sufficiently evolved to form a religious narrative?"), and the social benefits of group bonding and healing rituals, drawing examples from nonhuman primate groups.[57]

There is no consensus on when, exactly, monotheism appeared, although it's evidently a relatively recent idea. One theory, originally formulated by Sigmund Freud, was that monotheism originated with the Egyptian Pharaoh Akhenaten, who founded a short-lived but memorable monotheistic Sun cult.[58] Another theory, which enjoyed some popularity in the 17th and 18th centuries, was that the doctrine of the *monos theos*, the One God, was taught all along in secret among the priestly and royal elite in the ancient world, who knew the truth behind the polytheistic religion of the masses. Proponents of this theory believed (in the words of Egyptologist Jan Assmann) that the "so-called revelation [at Sinai] was nothing more than a huge open-air performance of an initiation into the greater mysteries, meant not for a select few, but for a whole people."[59] They thus traced the origins of the Torah to Egyptian Mysteries.[60]

Whatever the truth may have been, it's clear that until relatively recently in human history (sometime after ca. 1400 BCE), aspects of nature – especially animals, geographical features, the weather, stars and planets – formed the core *dramatis personae* of the majority of human religious stories.

The Divine King

The development of the state and the complex of symbolism surrounding kingship were of pivotal importance in the ancient history of religion. In his Pulitzer Prize-winning book of human history, *Guns, Germs and Steel*, Jared Diamond described the theory of how human groups develop from bands to tribes, tribes to chiefdoms, and from chiefdoms to states (a category which includes kingdoms). His analysis focused, somewhat controversially, on the critical contributing factors of food production and warfare: tribes that were effective in producing food were able to grow and expand, while concurrently wars often contributed to population growth through alliances and conquests. The type of social organization utilized (tribe, chiefdom or state) is largely a factor of population size: tribal government is only workable in groups of up to a few hundred people, chiefdoms in groups of one to ten thousand, and states are generally formed of 50,000 or more people.[61]

In many ancient cultures, the king was revered as a divine or semi-divine being, a son of the gods. The Sacred King was seen to continue beyond the grave in his role as orderer of the cosmos and protector from chaos. This deification of the monarch was a direct extension of the very ancient practice of ancestor worship.[62]

In its most general application, *ancestor worship* refers to "religious practices concerned with the belief that dead forebears can in some way influence the living."[63] Most often, it refers to the practice of "caring for the souls of the departed by offerings... to benefit them in the underworld kingdom of the

83

dead...."[64] Special reverence is often directed toward deceased leaders or heads of household, who are believed to continue in a protective role beyond the grave and to maintain the kinship hierarchy that is practiced by the society.[65] Although his role varied in its details, the king always held a special place in religion just as he held a unique place in society. In ancient Mesopotamia, the king was seen as holding the highest place among human priests in the divine court, of which his own court was the terrestrial reflection and outward symbol. In ancient Egypt the king was viewed as a god, and in Greco-Roman religion the king often became deified after death, with a cult on earth devoted to his service and worship. The kingdom of the gods, in turn, was often perceived as being in the same structure as the human kingdom: the gods were a kin group with a king at their head who lived in a palace that had guards, etc.; he had a queen and advisers, held court and had divine feasts just like his human representative, the terrestrial king.

The Royal Hunt

Hunting was the sport of kings and nobility in ancient Egypt and Mesopotamia – as in Asia, Europe and elsewhere – providing a forum for the king to display his prowess in a way that was explicitly linked to war. Among the many kinds of large and small game hunted for sport by royalty, lions were particularly prized as the kind of dangerous opponents truly fit for kings and heroes. In the following summary, I have relied on the exemplary study of Thomas T. Allsen, *The Royal Hunt in Eurasian History.*[66]

The royal hunt was a sporting activity performed by

the king with his attendants as a leisure pursuit; the hunt was
not for food, and in fact a great stigma was attached to noble
houses that were reduced to hunting for subsistence. The
hunt rather was a form of political theater, a public relations
campaign in which the king demonstrated his power over
the land and his right to claim a position of leadership among
the people. Enormous pressure was sometimes placed on a
young prince to produce a spectacular kill, particularly of a
lion or an equally dangerous animal. This would not only
establish a reputation for him as a legendary hunter, it would
further demonstrate his lordship of the land and his ability
to protect the kingdom from the real threats that might face
it. (In many places, such threats could include actual lions,
which the nobility were expected to exterminate if they
became a nuisance).

Animals were not always adversaries, but sometimes
acted as guardians of kings and heroes in myth, or stood
themselves as symbols of kingship. The lion, in addition to
being a notable object of the royal hunt, also could serve as a
symbol of the king, particularly in India and in Buddhism. It
resided at many courts as a dramatic sort of pet: "lions were
kept as 'court pets' in ancient Egypt and several pharaohs of
the thirteenth and twelfth centuries are pictured with tamed
lions beside their thrones or running beside their horse
or chariot. In later centuries there were lions kept in the
Byzantine, Seljuk, and Safavid courts, sometimes together
with tigers and leopards."[67] Such theatrical displays were
meant not only to intimidate the king's enemies, but further
served as a demonstration of his control over wild nature,
and acted implicitly as a symbol of the triumph of order over
chaos.

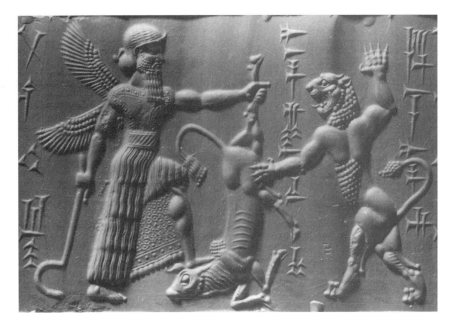

Fig. 10. *Winged Hero with Scimitar, Bull and Lion. Cylinder seal from southern Mesopotamia, 7th century BCE. The Pierpont Morgan Library, New York. Morgan Seal 747.*

The Master of Animals

The Master of Animals is one of the most widespread and enduring motifs in the art of the ancient Near East. In such scenes a human hero is shown in a dominant position over an (often dangerous) animal. The animal is sometimes inverted so the hero is holding it up by a back leg, and one foot rests on the animal's head in a common pose of subjugation; in another frequent variation on the theme, the hero is shown with a symmetrical pair of animals, sometimes lions or griffins, on either side of him. Although the animals that

appear in such scenes varied somewhat and could include a gazelle, goat, deer and many others, by far the most common animals depicted were the bull and lion. Frequently two figures appear, one of whom is human and usually fights a bull, while the other is a bull-man, usually in combat with a lion. Scholars emphasize that such figures can rarely be identified with any particular historical or mythological characters.[68] In the past it was common to assume that such figures were Gilgamesh and Enkidu, and the bull the Bull of Heaven, but today such identifications are reserved for a few unambiguous and exceedingly rare examples.

The Divine Shepherd

The metaphor of God as a shepherd is familiar to many through the 23rd Psalm:

> The Lord is my shepherd;
>> I shall not want.
> He makes me to lie down in green pastures;
>> He leads me beside the still waters.
> He restores my soul;
>> He leads me in the paths of righteousness
>> For His name's sake.
> Yea, though I walk through the valley of the
>> shadow of death,
>> I will fear no evil, for You are with me;
> Your rod and Your staff, they comfort me...[69]

That Jesus Christ was not only sacrificial lamb but also divine shepherd to God's people is a matter of faith for Christians. "I am the good shepherd," he says, in John 10:11. "The good shepherd gives His life for the sheep." And John 21 offers the following exchange:

> ...Jesus said to Simon Peter, "Simon, son of Jonah,
>> do you love Me more than these?"
> He said to Him, "Yes, Lord;
>> You know that I love You."
> He said to him, "Feed My lambs."
> He said to him again a second time, "Simon, son of Jonah,
>> do you love Me?"
> He said to Him, "Yes, Lord;
>> You know that I love You."
> He said to him, "Tend My sheep."
> He said to him the third time, "Simon, son of Jonah,
>> do you love Me?" Peter was grieved because
>> He said to him the third time, "Do you love Me?"
> And he said to Him, "Lord, You know all things;
>> You know that I love You."
> Jesus said to him, "Feed My sheep."

The metaphor of a god or king as shepherd has a long history that reaches at least as far back as the 24th century BCE in Mesopotamia. It appears frequently in the Hebrew scriptures, with a majority of instances occurring in the Prophets. The first appearance of prophetic shepherding in the Hebrew Bible is in the Torah (the first five books, Genesis through Deuteronomy, which are traditionally attributed to Moses). The patriarch Jacob works, presumably

as a shepherd, for his father-in-law Laban, and the same pattern is repeated in the story of Moses, who shepherds the flock of his father-in-law Jethro prior to the theophany in the Burning Bush and his call to prophecy.[70]

The excerpt from the 23rd Psalm, quoted above, makes a significant connection between the divine shepherd and the survival of the soul in death.[71] God is explicitly shepherding His people through the perils of death, allegorized as a valley.[72] A similar meaning was attached to the shepherd in ancient Greece, through the figure of Hermes Psychopompos, a ram-bearing (*kriophoros*) shepherd who carried the souls of the dead to the underworld.[73]

This image of the divine shepherd leading his flock through death to elysian pastures attained a unique prominence under Christianity, where the shepherding of Christ was understood as a messianic act of salvation from sin and all forms of suffering.

> They will hunger no longer, nor thirst anymore; nor will the sun beat down on them, nor any heat; for the Lamb in the center of the throne will be their shepherd, and will guide them to springs of the water of life; and God will wipe every tear from their eyes.[74]

The earliest known example of the use of the god-as-shepherd metaphor is from an inscription of Uruinimgina, King of Lagash, ca. 2350 BCE, in which the terms "shepherdship" and "kingship" were used synonymously. "From the end of the third millennium BCE onwards in Mesopotamia the monarch was thought of as the 'shepherd of his people.'"[75],

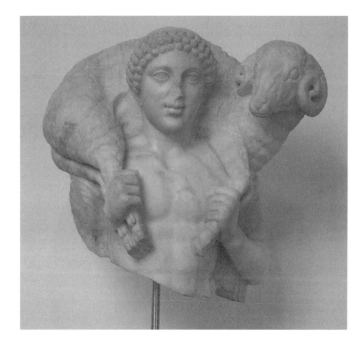

Fig. 11. *Hermes Kriophoros, bearing the souls of the dead to the underworld. Rome, early 5th century CE.*

The metaphor was applied to gods as well as the king, and referred at different times to the shepherd's role as guardian, tender (provider of sustenance and comfort) and herdsman.

Joan G. Westenholz has provided a translation of another early example of the metaphor's use, from an Old Sumerian vase inscription from the king Lugalzagesi (ca. 2259 – 2235 BCE):

> For my sake: may the countryside lie down in the grassy pasture, may the people become as

widespread as the grass, may the nipples of heaven function properly, and the homeland gaze upon a goodly earth! May [An and Enlil] never alter the propitious destiny they have determined for me! May I always be the leading shepherd.

Note the parallel image of the flock lying down in grassy pastures in the above inscription (a common image in Mesopotamian royal shepherding) and the second line of Psalm 23.

Joachim Jeremias placed the ancient Israelite use of the metaphor in its experiential context:

> Throughout the biblical period tending flocks, with agriculture, was in Palestine the basis of the economy. The dryness of the ground made it necessary for the flocks of sheep and cattle to move about during the rainless summer and to stay for months at a time in isolated areas far from the dwelling of the owner. Hence the herding of the sheep was an independent and responsible job; indeed, in view of the threat of wild beasts and robbers it could even be dangerous. Sometimes the owner himself or his sons did the job, but usually it was done by hired shepherds...[76]

Thus the image was powerfully grounded in the life experiences of the Biblical authors and their audience. In India, Egypt and Iran, cattle appeared in a parallel role. Krishna is a cowherd tending his famously sacred cattle; in Egypt the king was a cowherd but also in death a sacrificed bull; and in Iran the universe was said to have been created from the sacrifice of the primordial bull, and would end the same way.

8

Egyptian Mysteries

The ancient Egyptian cult of Osiris was one of the most enduring features of Egyptian culture, surviving in some form from the 3rd millennium BCE through the fall of the Roman Empire in the 7th century CE. The first written evidence of the cult is from the Fifth Dynasty (2500 – 2300 BCE), although the cult is believed to have existed long before its appearance in the historical record.[77] Unfortunately, there is no surviving narrative that relates the complete myth of Osiris until very late, from the 8th century BCE and onward, but historians have been able to piece together earlier versions from collected statements in spells and ritual texts.

The main characters in the drama are the gods Horus and Set, brothers, and Horus' wife Isis. Horus had inherited the throne of kingship through a lineage of divine ancestors, but was apparently the first in the family to have a brother to contend for the throne. Set was jealous of his brother's inheritance, and desiring the kingdom for himself, slew and

dismembered Horus, scattering the pieces of his brother's body in the Nile. When Isis heard of her husband's murder, in grief she collected his dismembered parts from the river (later traditions add that the goddess was able to locate all of her husband's body parts except the penis, for which she fashioned a postmortem replacement). Isis pieced the body back together – and the goddess's intense love for her husband resurrected him from death, albeit no longer as a living king but as ruler of the underworld. In death the king was now known by the name Osiris.

The goddess conceived a son from Osiris, and he was born as the new Horus, king of Egypt. In this manner, all of Egypt's living Pharaohs were identified with the god Horus, while the king's father was believed to ascend the throne in the underworld as the Osiris-king.

The existence of the Egyptian state was traditionally said to have originated from the union of Upper and Lower Egypt, near the end of the 4th millennium BCE. This idea of "unification" was integral to the Egyptian concept of existence itself. The human body was conceived as being made up of various parts that were all held together by the heart and blood. When the heart stopped beating at death, the various parts were then seen as "dismembered," and had to be treated in a certain ritualized way to bring them back together and assure the individual's survival in the afterlife. In addition to the body, the more spiritual or intangible aspect of man was said to be composed of the *ka* and the *ba*, which were his "vital energy" and something akin to a spirit, envisioned as a bird which was able to visit and travel about the world of the living. The *ka* and the *ba* needed the body to survive, however, and this was the reason behind the practice of

mummification, which essentially turned the corpse into a statue to house the *ka* and *ba* for eternity.[78]

Jan Assmann explains:

> The stopping of the heart brought an end to the integration in the limbs, which now fell apart into a disparate multiplicity. The myth dramatized this condition, telling how Seth [Set] slew his brother Osiris, tore his body into pieces, and scattered his limbs throughout Egypt. In the embalming ritual, this myth was played out for each deceased person... Myths of dismemberment are attested throughout the world, especially in the context of shamanistic rituals, and they have been interpreted as reflections of this sort of burial customs. In the meantime, it has been recognized that in Egyptian texts, this talk of the collecting and piecing together of that which had been torn up and scattered is to be understood symbolically.[79]

American psychonauts Dennis and Terence McKenna described the experience of shamanic initiation in their counterculture classic, *The Invisible Landscape*:

> The novice... [will] begin to undergo initiatory sickness and trance; he will lie as though dead or in deep sleep for days on end. During this time, he is approached in dreams by his helping spirits and may receive instructions from them. Invariably during this prolonged trance the novice will undergo an episode of mystical death and resurrection: He may

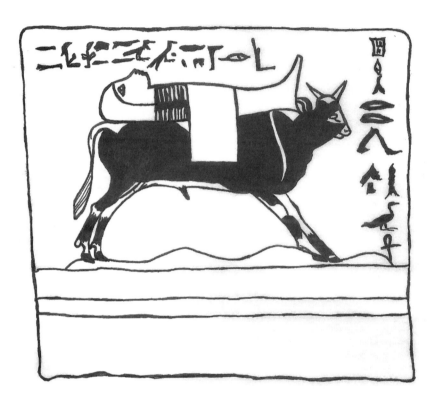

Fig. 12. *Apis bull carrying the mummy of the desceased to the underworld. Painting on the inner wooden coffin of Lady Tabakenkhonsu. Deir-al Bahari, early 7th century BCE. Drawing by S. Larisa Odins-Lucas, after Houlihan (1996).*

see himself reduced to a skeleton and then clothed with new flesh; or he may see himself boiled in a cauldron, devoured by the spirits, and then made whole again; or he may imagine himself being operated on by the spirits, his organs removed and replaced with "magical stones," and then sewn up again. Although the particular motifs may vary between cultures and even individuals, the general symbolism is clear: The novice shaman undergoes a symbolic death and resurrection...

The McKennas quoted an example from Siberia:

The Tungus say of their shamans: "Before a man becomes a shaman he is sick for a long time. His understanding becomes confused. The shamanistic ancestors of his clan come, hack him to bits, tear him apart, cut his flesh in pieces, drink his blood. They cut off his head and throw it in the oven, in which various iron appurtenances of his costume are made red-hot and then forged. This cutting up is carried out somewhere in the upper world by the shaman ancestors. He alone receives the gift of shamanhood who has shaman ancestors in his clan, who pass it on from generation to generation; and only when these have cut up his body and examined his bones can he begin to shamanize."[80]

Shamanism seems to me to be a strong candidate to consider for the ultimate prehistoric origins of the Osiris cult.[81]

A series of texts from the tombs of Egyptian royalty and nobility – the Old Kingdom *Pyramid Texts*, Middle Kingdom *Coffin Texts*, and the New Kingdom *Book of Coming Forth By Day* (*Book of the Dead*), among several other later texts – preserve details of the Egyptians' beliefs about the afterlife as they developed through time. These included spells for ensuring the dead's safe passage through the underworld to eternal life, and were originally reserved for the use of kings – and, sometimes, their queens – but were eventually made available to nobility and, later, the community in general. One early text, known as the *Book of Two Ways*, has been found painted on the inside of coffins from Heliopolis, presumably as a visual aid for the newly deceased. These books (which survive in several versions) included a map of the soul's journey in death, and are a valuable addition to knowledge of the geography of the early Egyptian underworld. Egyptologist Geraldine Pinch has remarked of these maps that "[t]he extraordinary visual detail in which the afterlife is presented has a hallucinatory quality similar to that of the 'spirit voyages' induced by shamans in many cultures."[82]

While the earth was viewed as flat, the sun (the god Re) was seen as making a circular journey around it, emerging from the underworld every morning from a gate in the east and descending again every night through a gate in the west. The deceased king was believed to join the sun god in his celestial boat to sail across the sky to the entrance to the underworld (if it seems odd that the sun should use a boat to sail through the sky, bear in mind that the heavens and the underworld were conceived as oceans). The king, with the sun, would pass through fiery gates and encounter various

Fig. 13. *The ancient Egyptian* Book of Two Ways, *shown here without hieroglyphic inscriptions. In the top right sections, the deceased is described as traveling to the sun god in the east, where he joins Re in his celestial boat. The two winding paths in the middle of the top half represent the path of the sun through the sky (above) and underworld (below), paths fraught with demons whose names the deceased must know to pass them safely. If he succeeds, he earns eternal life, and in the sections to the left of the two ways the deceased goes on to become identified with Osiris. In the bottom panel, starting again from the right, the deceased passes through a series of seven gates before arriving first at a realm of immortals who do not ascend to the sky, then to the ship of Osiris and finally to the ark of gods. The text concludes with a spell in which the All-Lord enumerates his gifts to mankind and praises the deceased for whom the text was written. Illustration from* The Ancient Egyptian Book of Two Ways *by Leonard H. Lesko, © 1973 by the Regents of the University of California. Published by the University of California Press.*

demons and hostile deities whose names the king needed to know in order to pass them safely. Armed with the necessary information from the spells, he would complete the circle to re-emerge from the east, pass through a series of seven gates and ascend to the sky, being reborn with the stars as they rose from the underworld together.

Egyptologist J. P. Allen interpreted the structure of the tomb of the Pharaoh Unas as an architectural model of the underworld-journey. As summarized by Christopher Eyre:

> Allen's analysis of the sequence of spells in the pyramid of Unas defines the architecture as a material representation of the passage of the king through death to resurrection, exploiting themes familiar in the Underworld Books of the New Kingdom. From the darkness of the earth he passes to life in the light of the sky, progressing from the burial chamber as underworld through the antechamber as horizon... through the doorway leading to the corridor – ascending by ladder – to heaven, or passing like the setting sun from the west to his rising from the mouth of the horizon in the east, or exploiting the image of the king passing from his sarcophagus – the womb of Nut – through her vulva to birth at the door of the horizon.[83]

In the East, if all went well, he would be united with Osiris in the constellation Orion. In the Pyramid Texts of Pepi I we find a clear example of the equation of Osiris with the constellation Orion:

Look, He has come as Orion.
Look, Osiris has come as Orion.[84]

The texts from various pyramids make it clear that this was a common equation, and that the constellation of Orion was viewed as the *ba* of Osiris.

The sacred bull was another way that Osiris was believed to manifest his *ba*. The best-known ancient Egyptian bull cults were those of Apis and Mnevis. These cults are sometimes considered to have been survivals from primitive religion. The bull-sacrifice appears to have been an element of religious practice in the Osiris cult; Jan Assmann explains:

> From the Coffin Texts... it emerges clearly that the legal conflict with Seth and the latter's condemnation were accompanied by a ritual slaughter. Seth's execution was symbolically carried out in the form of the slaughter of an ox. Nearly two thousand years later, we again encounter these same spells at the end of a different mortuary liturgy on papyri of the Graeco-Roman era. We can thus conclude that this ritual slaughter was the typical conclusion of a mortuary liturgy.[85]

In one such Egyptian spell – Pyramid Texts, Utterance 580 – we find both Osiris and Seth referred to as having been killed in the form of a bull. A ritual feast follows the slaughter – indeed, dismemberment – of the bull representing Seth, which atones the murder of the Osiris-King.

Utterance 580

An offering text in which the sacrificial ox represents Seth. Address to the ox by the priest impersonating Horus.

O you who smote my father, who killed one greater than you, you have smitten my father, you have killed one greater than you.

Address to the dead king

O my father Osiris this King, I have smitten for you him who smote you as an ox; I have killed for you him who killed you as a wild bull; I have broken for you him who broke you as a long-horn on whose back you were, as a subjected bull. He who stretched you out is a stretched bull; he who shot you is a bull to be shot; he who made you deaf is a deaf bull. I have cut off its head, I have cut off its tail, I have cut off its arms, I have cut off its legs. Its upper foreleg is on Khopr, its lower foreleg [belongs to Atum], father of the gods, its haunches belong to Shu and Tefenet... its thighs belong to Isis and Nephthys... What of it the gods have left over belongs to the Souls of Nekhen and the Souls of Pe. May we eat, may we eat the red ox for the passage of the lake which Horus made for his father Osiris this King.[86]

In this spell the dead king is referred to as both being the bull and standing on the bull.[87]

Death and Initiation

Assmann has described how death was identified as an initiation into the mysteries of the underworld in ancient Egyptian mortuary literature.[88] He quotes as evidence a refrain repeated in the *Book of the Dead*:

> The mysteries of the netherworld,
> Initiation into the mysteries of the realm of the dead.

Assmann points out that the information transmitted in the ancient Egyptian netherworld literature was, at least at first, only known to royalty and priests, and can be seen as having formed an element of a sort of elite "mystery cult." He cites a passage from the *Book of the Dead* in which an explicit parallel is drawn between the earthly priesthood and the service rendered to the Sun god by the deceased in the afterlife. The secret knowledge transmitted in this "brotherhood" was specifically concerned with the attainment of immortality.

While it is fairly certain that this esoteric tradition in ancient Egypt had no connection with the precession of the equinoxes or the circle of the zodiac, it did have an exclusive membership and rituals that were known only to initiates; it was immediately concerned with death and resurrection; it involved a ritual bull-slaughter; and it had an unambiguous connection to the constellation of Orion (Egyptian, *Sahu*).

9

Mesopotamia the Far-Away

In the present chapter, we'll look at a selection of myths from Mesopotamia, the birthplace of astrology, with the intention of discerning the outline of any potential mystical doctrine that may be preserved in the fragments that remain of this obscure and enigmatic culture.

In Mesopotamian astrology, the constellation that later came to be called Orion by the Greeks was called *sipa.zi.an.na*, "True Shepherd of Heaven" or "True Shepherd of Anu" (Akk. *šitaddalu*). This was sometimes identified with the shepherd Dumuzi, the spouse of Inanna[89] (the pair of whom are similar enough to Osiris and Isis to merit closer comparison). "True Shepherd," *sipa.zi*, was a common title of the Mesopotamian king, as we touched on earlier.

Kingship in Mesopotamia was said to have descended from heaven to the shepherd-king Etana. The versions of the Etana legend that survive are unfortunately badly fragmented, but it appears that in the opening lines

of this legend, the gods are planning the first city, and Ishtar (Inanna) descends to earth to seek out the first king.

From an Old Babylonian version:

> The great Anunna-gods, ordainers of destiny,
> Sat taking counsel with respect to the land…

> Among all the teeming peoples they had
> established no king…

> Scepter, crown, headdress, and staff
> Were set before Anu in heaven.[90]

> There was no ruler for the people.
> Kingship came down from heaven.
> …Ishtar looked for a king…[91]

Note that the shepherd's staff is listed here among the royal insignia that sit before the king of gods, Anu.

Then, from a Late Version:

> Ishtar [came down from heaven? to seek]
> a shepherd,
> And sought for a king e[verywhere].
> Enlil examined the dais of(?) Etana,
> The man whom Ishtar st[eadfastly]…

> "[Let] king[ship] be established in the land,
> let the heart of Kish [be joyful]."
> Kinship, the radiant crown, throne, [][92]

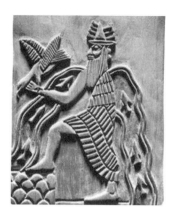

Fig. 14. *Wisdom god Ea, holding a bird, with water streaming from his shoulders. This deity may have been depicted in the early constellation of Aquarius.*

Presumably, in this last line, kingship is descending from heaven.

As king, Etana built a shrine for the storm-god Adad, and a poplar tree grew in the shade of the shrine. An eagle settled in the tree's crown, and a serpent nested at its root. The eagle and snake swore an oath of friendship, vowing to assist one another in raising their young, and each shortly thereafter produced offspring. All went well for a time, as the eagle and snake hunted and shared food among their children; but after the eagle's young had flourished and grown fat, one day while the serpent was away the eagle decided to eat the serpent's children. When the serpent returned to find its children devoured and its nest torn apart with obvious talon marks, in grief it called upon the sun god Shamash to witness the violation of their oath and exact justice. Shamash advised the serpent to slaughter a bull and hide within its entrails;

when the eagle descended to poke around inside it for the juiciest meat, the serpent was to seize it, pluck out its feathers and throw it in a pit to starve to death.

The plan was executed successfully, with the eagle ending up featherless in the pit. The eagle called on Shamash for mercy; Shamash said he could not help the eagle, whose punishment was well deserved, but indicated that he would send a man to help it. Meanwhile, Etana was calling upon Shamash to give him the "plant of life," which would enable him to produce an heir. Shamash recommended that Etana find the eagle in the netherworld pit, and rescue it in exchange for the plant. This Etana did, and together they flew to the heavens, past the seven gates of the gods.

Here the story breaks off and we do not know how it ends. However, we may surmise that Etana was somehow successful in securing the plant, since he later had an heir.

Inanna's Descent to the Underworld

In this well-known story, the goddess Inanna journeyed to the underworld, where her sister Ereshkigal was Queen. At the entrance to the underworld, she threatened to break down the gates so that the dead would mixed with the living. Intimidated by her threat, the gatekeepers allowed her to pass. She descended through seven gates, at each one being stripped of adornments from her tiara down to her loincloth. When she arrived in the presence of Ereshkigal, something happened (it is unclear what) and Ereshkigal set loose a legion of demons to kill Inanna. Meanwhile, back on earth, the animals and humans were no longer mating since Inanna was in the realm of the dead. The wisdom

god Ea created a male creature who was able to descend to the underworld and so charm Ereshkigal that she offered to grant him any wish; he requested the return of Inanna, which enraged Ereshkigal. She complied, but placed him under a heavy curse. Inanna was sprinkled with the Water of Life and allowed to return from the underworld, on the condition that she must send someone back to take her place. While Inanna's life and adornments were being restored, Ereshkigal ordered a vizier to remove the signs of mourning from Inanna's lover Tammuz (Dumuzi) and make him festive with ladies. When Inanna returned to find him apparently undisturbed by her death, she impulsively offered him as her substitute in the underworld. Subsequently, however, his fate was mitigated and he and his sister Geshtinanna were made to alternate residence in the underworld, each remaining for six months out of the year. Dumuzi in this story is called both "Wild Bull" and "Shepherd," the latter connecting him with the living king and creating a further link (in addition to the Etana legend, and the *hieros gamos*, not discussed here) between the king and Inanna.

Inanna and the Huluppu Tree

The story of Inanna and the Huluppu tree appears at the beginning of a Sumerian poem, known as "Bilgames and the Netherworld," which was among the early sources drawn upon for the composition of the standard Babylonian Epic of Gilgamesh.

In the beginning of the Sumerian poem[93] (a part of the story that is excluded from the Babylonian version), we are told that in mythical times a single tree grew on the

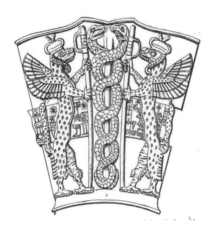

Fig. 15. *Vase dedicated to the underworld deity Ningishzida from King Gudea of Lagash, 22nd century BCE. This provides one of the earliest-known examples of the caduceus symbol.*

banks of the Euphrates river. Inanna picked up the tree and brought it to her garden in Uruk, where she planted it and watered it (not with her hands, we are told, but with her foot). Inanna eagerly anticipated the imperial uses to which she meant to put the timber:

> She said, 'How long until I sit on a pure throne?'
> She said, 'How long until I lie on a pure bed?'

Ten years later, the tree was growing healthily, but a serpent had made its nest in the roots, a thunderbird was raising its young in the branches and a demon had made its home in the trunk. In dismay, the goddess turned to the Sun god for help; she related the story to him, but he did not help her. Next she turned to the warrior Bilgames (Gilgamesh) and

related the story again to him. Bilgames took up his axe and killed the serpent at the root of the tree; the thunderbird and its young flew away to a new home in the mountain, and the demon in the trunk of the tree fled to the wasteland.

> As for the tree, he tore it out at the roots and
> snapped off its branches.
> The sons of his city who had come with him
> lopped off its branches, lashed them together.

Bilgames kept the base and a branch for himself and formed them into some kind of toys – it is unclear exactly what he made, but some kind of stick and ball for playing a ball game seem to be the most likely candidates, with vaguely sexual overtones. The men of the city played for all of the first day, carrying Bilgames around on their backs, and Bilgames intended to continue their game the next morning, but the women protested, and their complaints caused the toys to fall into the netherworld. Bilgames was grief-stricken, and his servant Enkidu offered to retrieve the toys. Enkidu descended to the netherworld, became trapped, and was rescued by the Sun god; this episode in the story is followed by a lengthy dialogue between Bilgames and Enkidu describing the netherworld (where some shades are tortured and others happy, mostly depending on how they died and how many sons they had left behind in the world to make offerings to them). The poem breaks off abruptly, but one version includes three lines at the end that link it to the beginning of "Bilgames and Huwawa," an earlier Sumerian version of the conflict with Humbaba in the Babylonian *Epic of Gilgamesh*.

The Epic of Gilgamesh

The *Epic of Gilgamesh* is one of the most significant of the surviving works of ancient Mesopotamian literature. Preserved in cuneiform on twelve clay tablets, the Epic tells a mythologized story of the historical king Gilgamesh, who lived in the 27th century BCE. A latter episode in the narrative draws on the 18th century BCE *Atrahasis* epic, which includes a Flood story that some scholars believe was the source for the deluge account in Genesis. Where the first part of the Gilgamesh epic focuses on the exploits of the king, the latter part develops into a prototypical tale about a quest for immortality that some scholars believe was a source for similar stories in the *Alexander Romance, Arabian Nights* and Holy Grail traditions.[94] It has further been offered as a prototype for the labors of Hercules. For these reasons we will examine this story here in some detail.

In the opening passage, we learn of Gilgamesh's bull-like power:

> Surpassing all other kings, heroic in stature,
> brave scion of Uruk, wild bull on the rampage!...

> Who is there can rival his kingly standing,
> and say like Gilgamesh, "It is I am the king?"
> Gilgamesh was his name from the day he was born,
> two-thirds of him god and one third human.[95]
> *(I.29-30, 45-49)*

Gilgamesh's passions were appropriately superhuman. He took every young man to task in contest, and his lusts let "no girl go free to her bridegroom." The women's

complaints about his superhuman appetites reached the ears of the gods, who devised a plan to distract him.

The sky-god Anu implored the goddess of creation, Aruru, to create Gilgamesh's equal: "let him be a match for the storm of his heart, / let them vie with each other, so Uruk may be rested!"*(I.97 – 98).*

So Aruru created Enkidu to be Gilgamesh's double. He had a rough body like an animal and long hair; he grazed with the gazelles on grass and drank at the water hole with the game. Enkidu lived like this, feral, for a time, until one day he encountered a hunter. The hunter was troubled by the encounter, and told his father that Enkidu had been helping the animals escape from his traps so he was unable to do his work. His father devised a plan to ensnare Enkidu. He advised him:

> My son, in the city of Uruk go, seek out Gilgamesh!
>
> ...do not rely on the strength of a man!
> Go, my son, and fetch Shamhat the harlot,
> > her allure is a match for even the mighty!
>
> When the herd comes down to the water hole,
> > she should strip off her raiment
> > to reveal her charms.
> He will see her, and will approach her,
> > his herd will spurn him,
> > though he grew up amongst it. *(I.135,139-145)*

The Trapper did as his father suggested, and the plan worked. Enkidu lay with the woman of

pleasure, spending his passion with her for an entire week uninterrupted. Then, when he was satisfied, he went to return to his herd, but to his dismay he discovered that the wild animals now ran from him.

> Enkidu had defiled his body so pure,
>> his legs stood still, though his herd was in motion.
> Enkidu was weakened, could not run as before,
>> but now he had reason, and wide understanding.
>> *(I.199-202).*

Enkidu returned to the woman, who told him of Gilgamesh, the king's great strength and his harassment of the people. She asked him to come with her to Uruk, and Enkidu agreed, voicing his intention to challenge Gilgamesh and his urban status quo. But the woman told him: "O Enkidu, cast aside your sinful thoughts! Gilgamesh it is whom divine Shamash loves. The gods Anu, Enlil and Ea have broadened his wisdom"*(I.240-243)*. She informed him that Gilgamesh had already had two dreams about Enkidu's coming, which she related in some detail.

Next, Enkidu and Shamhat spent some time with a community of shepherds, where Enkidu learned to eat and drink bread and ale, barbers tamed his hair, and he put on clothing so that he became "like a warrior, he took up his weapon to do battle with lions." His first contribution to the community was to hunt the lions and wolves that prowled around the camp at night, while even the senior shepherds slept soundly. But soon he was recalled to his original goal, when he saw a man passing and inquired where he was going. The man informed him that he was headed to a wedding in

Uruk, but mentioned that before it would take place, Gilgamesh the king would take his *droit de seigneur* with the bride, laying with her first so that the groom would have her second.

Enkidu, enraged by this, set out immediately for Uruk. He entered the city, and the people were awestruck when they saw him, proclaiming that Gilgamesh's equal had arrived.

Meanwhile, a bed was laid out for the Queen of Heaven.[96] Gilgamesh made his way toward the bride, but Enkidu was waiting in the street, and put out his foot to block his way. (I understand this scene as a challenge to Gilgamesh's kingship). The two wrestled, and Gilgamesh came out the victor. Enkidu proclaimed Gilgamesh's superior power, and the two embraced and became BFF's.

There is another break in the narrative, and when it picks up, Gilgamesh has hatched a plan to travel to the Forest of Cedar in order to kill the monster Humbaba, ridding the land of evil and establishing a name for himself (an earlier version of the story explains that he desired to do this because he had realized that life is fleeting). Enkidu expressed terror at the prospect of facing this ferocious monster, who was created by Enlil to protect the forest. He pleaded:

> "Humbaba, his voice is the Deluge,
>> his speech is fire, and his breath is death!
> Why do you desire to do this thing?" (*II.110-114*)

But Gilgamesh was unimpressed:

"Why, my friend, do you speak like a weakling?
 With your spineless words
 you make me despondent...

"You were born and grew up in the wild:
 even lions were afraid of you..."
 (II.232-233, 237-238)

Gilgamesh, determined on his goal, consulted with the elders of Uruk, and then his mother, the goddess Ninsun. The goddess went up to the roof of the Sublime Palace and made a long supplication to Shamash for Gilgamesh's safety and victory. Gilgamesh and Enkidu made their preparations and set off (leaving Uruk, for the time, without a king).

Along the way, as they made the long journey, Gilgamesh and Enkidu performed rituals each night to produce good omens through dreams. Gilgamesh, however, had troubling dreams, which Enkidu then interpreted for him as really being good dreams. Their anxiety mounted as they approached the Forest, until finally they reached their destination and faced the monster.

"Why have you come here into my presence?" Humbaba growled. He accused Enkidu, former citizen of the wild, of high treason:

"Come, Enkidu...
 In your youth I watched you...

"Now in treachery you bring before me Gilgamesh,
 and stand there, Enkidu,
 like a warlike stranger!" *(V.89-92)*

116

The monster's speech succeeded in intimidating Enkidu, but Gilgamesh pressed on unafraid. Shamash joined in the ensuing conflict, sending his thirteen demons the South Wind, North Wind, Tempest, Frost-Wind, etc., to blind the monster. When he saw that he was bested, Humbaba began to plead for his life, begging Enkidu to tell Gilgamesh to have mercy. But Enkidu urged Gilgamesh to finish the monster quickly:

> "Finish him, slay him, do away with his power,
>> Before Enlil the foremost hears what we do!...
> Establish for ever a fame that endures,
>> how Gilgamesh slew ferocious Humbaba!"
>> *(V.186-187, 189)*

Before receiving the deathblow, the monster uttered a curse:

> "May the pair of them not grow old,
>> besides Gilgamesh his friend,
>> none shall bury Enkidu!" *(V.256)*

The heroes then frolicked in the forest, cutting down the now-vulnerable cedars and uncovering the "secret abode of the gods." (Presumably the dwellings of the Anunnaki became exposed when the heroes pulled the enormous trees from the ground, leaving gaping holes that were so deep the underworld could be seen through them.) Enkidu requested Gilgamesh fell a lofty cedar for him, one reaching to the sky, from which he would make a fantastic door for the temple of Enlil, which the Euphrates would bear to the temple.

After they had finished their destruction of the forest, Gilgamesh washed up and exchanged his bloodstained clothes for clean ones. His beauty attracted the attention of the goddess Ishtar, who propositioned him and offered the king wealth and power as her husband. Gilgamesh not only declined, but elaborated the reasons for his rejection in an extended, humiliating stream of insults: "What bridegroom of yours did endure for ever?" He wondered. "What brave warrior of yours went up to the heavens? Come, let me tell you the tale of your lovers..." He launched into a list of all the goddess's previous failed relationships, which invariably ended in tragedy for the groom. "Must you love me also," he concluded, "and deal with me likewise?" *(VI.42-44, 79)*

The goddess was infuriated, and flew up to her father Anu in tears, complaining that Gilgamesh had scorned her and related a tale of slander and insults. Anu pointed out that she had provoked it. Ishtar demanded that Anu give her the Bull of Heaven (the constellation Taurus) to destroy Gilgamesh, and threatened to break down the gate of the netherworld so that the dead mixed with the living if he didn't comply. Anu expressed concern for the destruction the Bull would cause the people if he did give it to her, but Ishtar assured him she had already seen to the people's needs. Anu conceded, and Ishtar took the Bull down to Uruk.

The Bull of Heaven was a massive creature: he snorted once and a pit opened up that a hundred men fell into; twice and two hundred men fell; three times and Enkidu fell in up to his waist. He leapt out and seized the Bull by the horns. He tested its strength and called out to Gilgamesh to come slay the creature, by thrusting his knife between the horns

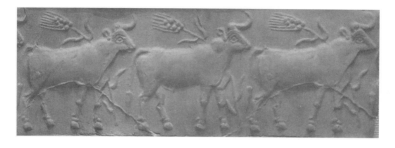

Fig. 16. *"Cattle in a Wheat Field." Cylinder seal impression. Uruk, 4th millennium BCE. Musee du Louvre, Paris, France. Photograph © 2007 Marie-Lan Nguyen/Wikimedia Commons.*

and the "slaughter-spot."

> Then Gilgamesh like a butcher, brave and skilful,
>> between the yoke of the horns and the
>> slaughter-spot he thrust in his knife.
>
> After they had slain the Bull of Heaven,
>> they bore its heart aloft and set it before Shamash...
>
> Ishtar went up on the wall of Uruk-the-Sheepfold,
>> hopping and stamping she wailed in woe:
> "Alas! Gilgamesh, who mocked me, has killed the
>> Bull of Heaven."
>
>> *(VI.145-148, 151-153)*

Enkidu heard the goddess's tantrum, and tore off the bull's haunch and hurled it at her, proclaiming, "If I could catch you also, I'd treat you the same..." (Here it's often pointed out that the goddess, who can only descend to the city wall, is clearly identified with the planet Venus).

Ishtar and the devotees of her temple set up mourning over the haunch of the Bull, while Gilgamesh assembled the craftsmen to admire the size of the horns.

That night, Enkidu dreamed that he had been cursed by the gods to die for his part in the slaying of Humbaba and the Bull of Heaven. Grasping the fact of his mortality for the first time in the face of death, Enkidu offered a long, mournful monologue in which he cursed the door he'd made for the temple of Enlil, which failed to save him, cursed the trapper who diminished his feral greatness, and issued a long stream of curses at the harlot who weakened and defiled him. Shamash answered from the sky that his curses against Shamhat were unjust, so Enkidu calmed down and balanced the (apparently irretrievable) curses against her with a stream of blessings.

The following night, Enkidu had a dream that he was dragged captive to the underworld by a mystical creature. The same day he had the dream," his strength was exhausted." He took to his bed ill, and over the next eleven days his sickness worsened. On the twelfth day he died.

Distraught, Gilgamesh performed the funerary rites for his friend, and then, from the fear of death that had set upon him, began to wander the wilderness in search of Utnapishtim the Far-Away, the only human ever to have been granted immortality by the gods. On the road, at a mountain pass, he encountered some lions, and grew afraid. He prayed to Sin, the moon god, for support, and in the morning woke up with renewed courage and slayed the lions.

Gilgamesh traveled to the twin mountains where the sun rises, Mount Mashu ("Twins"). There he encountered two scorpion-people, one male and one female, guarding

the gate of the sun's entrance. They marveled that he had made the journey to reach them – the first person ever to do so – and Gilgamesh persuaded them to let him pass.

Next he took the "Path of the Sun"[97] (a fantastically long tunnel through the mountain, covering a distance of "twelve double-hours") to the land of the gods. He found himself standing on the shore of an ocean, and wandered the coast until he found a tavern that was kept by a young woman who spotted him from afar and, immediately recognizing him as a bull-slayer, locked her gate and removed herself to the roof of the tavern. Gilgamesh called to her, threatening to break down the gate, and the woman asked his purpose in coming. He told her of Enkidu's death and his search for immortality, and asked for directions to Utnapishtim. She told him the sage lived across the ocean, but warned Gilgamesh that the Sun could make the journey but he would not be able to, since the Waters of Death lay between the two shores. She advised him to find Utnapishtim's ferryman, however, who might take him across.

After some difficulty, Gilgamesh eventually made it across with the ferryman's assistance. He related his woeful story to Utnapishtim, and Utnapishtim counseled him with words of wisdom. "Why, Gilgamesh, do you ever chase sorrow?" He wondered. Had he not enjoyed the best of everything the world has to offer? Unfortunately much of his speech is fragmentary, but in one surviving fragment he is pointing out that the gods do not sleep.

Gilgamesh next asked Utnapishtim how he found eternal life. Utnapishtim replied:

Let me disclose, O Gilgamesh, a matter most secret,
to you I will tell a mystery of gods. *(XI.9-10)*

He proceeded to relate the story of the Flood, and how he survived it. This long narrative arguably is the climax of the Epic.

Utnapishtim was confident Gilgamesh would not succeed at attaining immortality, but still offered: "For six days and seven nights, come, do without slumber!"

The hero tried and failed miserably, falling asleep the moment he sat down. He slept for seven days straight before Utnapishtim woke him.

"O Utnapishtim," Gilgamesh complained,

A thief has taken hold of my flesh!
For there in my bed-chamber Death does abide… *(XI.244)*

Utnapishtim cursed the ferryman who had brought Gilgamesh across, and then ordered him to wash Gilgamesh (who had become filthy during his wanderings) and dress him again in the garments of a king. As he mounted the boat and set off for home, Utnapishtim offered him a parting gift, another "secret… a mystery of gods."

Utnapishtim described a plant that, if he could possess it, would make him again as he was in his youth. Gilgamesh immediately tied rocks to his feet and plunged to the bottom of the ocean to look for the plant. He succeeded in obtaining it, and proclaimed it to be the "Plant of Heartbeat." Just as soon as he got back to Uruk, he said, he was going to give it to an old person and put it to the test.

On the journey back, however, when they stopped for the night –

> Gilgamesh found a pool whose water was cool
> > down he went into it, to bathe in the water.
> Of the plant's fragrance a snake caught scent,
> > came up in silence, and bore the plant off.
>
> As it turned away it sloughed its skin.
> > Then Gilgamesh sat down and wept… *(XI.302-307)*

The ferryman took Gilgamesh all the way back to the walls of Uruk, and there the story ends.

Comments

For over a hundred years, scholars have been debating James Frazer's concept of the "Dying and Rising God." This has significantly focused on establishing whether the death and resurrection of Christ can be seen as a unique event or whether there was a precedent for the theme in primitive nature worship. Completely independent of any kind of relationship with Christianity, there are compelling similarities between Dumuzi and Osiris that seem beyond coincidence. Both were associated with the king and with the constellation Orion; both appeared as a bull, died and became king in the underworld; the grief of the goddess is a major focus in the cults of both deities. Henri Frankfort's observation that the Mesopotamian king was usually not deified is an important distinction; and indeed the death of the king is a central concern of the *Epic of Gilgamesh*.

The use of vertical space in Etana is worth noting: the descent of the goddess to earth; the eagle's vertical relation to the serpent, and its descent of the tree to commit its crime; its descent into the netherworld pit, and subsequent rescue and ascent to heaven (specifically, the heaven of Ishtar). The sun, eagle, serpent, bull and king are central characters in this story, which is about death and fertility.

Trees figure prominently in several of these stories – including the serpent- and eagle-inhabited trees of Etana and of "Bilgames and the Netherworld," and the cedars of Huwawa/Humbaba in the various versions of that story. We know that the sacred palm tree was associated with the human spinal column in at least one Assyrian mystical text[98] – and while the trees here are not palm trees, in "Bilgames and the Netherworld" the tree does belong to Inanna (or rather is adopted by her), and there could be a speculative case for connecting her with the cedars in the Humbaba story through the juxtaposition of the two monster-slayings.

There is a cluster of symbolism in Mesopotamian myth involving the tree, goddess, sex, death and kingship that begs explanation. Simo Parpola's perception of the practice of Kabbalah in Mesopotamia was, as Andrew George describes it, a courageous thesis, but I don't think it's at all illegitimate to look to Mesopotamia and Egypt for the backgrounds of Jewish mysticism. I would also like to point out, independent of that subject, that I find again we are hovering strangely near to the themes explored by Frazer (tree worship, fertility, kingship, death and rebirth) in his antiquated treatise on the Dying God.

The Bull of Heaven, the constellation Taurus, was slain by the heroes Gilgamesh and Enkidu in the

Babylonian *Epic of Gilgamesh*. This Epic was a creative redaction of older stories that were originally independent, including "Bilgames and Huwawa," an earlier version of the slaying of Humbaba, and "Bilgames and the Bull of Heaven." Even though, in the latter tale, the heroes were aided by seven constellations (given to them by the sun-god) which led them to the Bull, I am still inclined to agree with George's conclusion that these stories were *originally* composed as songs performed for entertainment at the royal court. The killing of fantastic creatures seems to be more closely related to the Royal Hunt than to the ascent of the soul – particularly since Gilgamesh's stated intention is to establish a name for himself, which was a common reason for royalty (and all hunters) to produce a spectacular kill, such as that of a lion or Humbaba. It should be borne in mind however that kingship was said to have descended from heaven, so the king's struggle against the forces of chaos at the edge of civilization certainly could have had some subtle religious significance, both in myth and practice.

The image of the bull functioned here in its usual role as an over-arching metaphor for awesome power. The plot was deeply concerned with issues of masculinity and sex.[99] When the feral Enkidu laid with the harlot (a votary, by profession, of the Queen of Heaven and her "temple of love") the explicit consequence was a chronic loss of power, eventually culminating in death. In contrast, Gilgamesh, the more powerful of the two companions, rejected the goddess's propositions, triggering the series of events that led him to his quest for immortality. Prior to this event Gilgamesh was hardly virginal, but it was precisely because of his insatiable appetites for sex and sport that the women

125

of the kingdom first complained about him, inspiring the creation of Enkidu: his lust had left no wife to her husband, much in the same way that the Bull of Heaven's voracious appetite consumed all the water and grain leaving nothing for the people.

The lions in the story were much less prominent, and as far as I know there is no known Mesopotamian legend about the constellation Leo. Both Enkidu and Gilgamesh did slay lions in the Epic, and Gilgamesh wandered the wilderness clothed in the pelts of lions. There are similarities to the labors of Hercules (Hercules was a lion- and bull-slayer who, like Orion and Gilgamesh and other hunter-heroes, wore a lion's pelt), and in light of the Greco-Roman practice of deifying the hero-king, this seems like a line of inquiry worthy of development.

In *The East Face of Helicon*, Martin West offered an in-depth study of the Near Eastern influences on early Greek literature and mythology.[100] He saw evident similarities between the labors of Hercules and the *Epic of Gilgamesh*, as well as with the Hebrew story of the serpent and the trees of wisdom and immortality in the Garden of Eden. Even stronger, however, were the correlations between Hercules, Gilgamesh and the biblical Sampson (Hercules and Sampson, he observed in a footnote, were "already compared in antiquity"). He saw another promising forerunner of the labors of Hercules in the trophies of the Mesopotamian deity Ninurta. He gave little credence, however, to the idea that the labors were associated with constellations: "It seems out of the question that they could have been correlated with the signs of the zodiac before the fifth century at the earliest, and the correlation is not in fact documented until much later." He

allowed that Sampson's name is connected with the Sun, but saw no justification for interpreting Hercules this way; though there is a possibility that *Heracles* is derived from *heros*, "hero," and thence from the root **yer*, "year."

Continuing with Gilgamesh, it seems to me that the story of the Deluge has a mystical essence that could have been present from the earliest versions of the story. The version in the Babylonian Epic preserves large portions of *Atrahasis* unaltered. Unlike other stories in the Gilgamesh cycle, I believe *Atrahasis* may have been composed with a deliberately mystical intent.

Andrew George has cautiously offered the late 2nd millennium scribe Sin-leqi-unninni as the editor who redacted the Standard Babylonian Epic and infused it with a degree of existential depth that had been lacking in the earlier independent Bilgames tales.[101] He specifically attributes to Sin-leqi-unninni the Epic's moral that "wisdom is the prize of life." It seems to me that the same editor could also have consciously developed a mystical subtext in the narrative – and, in fact, the focus on *wisdom* strikes me as the very quintessence of Near Eastern mysticism. The degree to which the Mesopotamian scribal tradition included a mystical current has long been a matter of debate,[102] but I'm willing to consider its existence an open possibility.

IV

10

The Divine Harmony

In Mesopotamia, disease was believed to be caused by demonic beings that specialized in causing specific illnesses. Medical practice thus took the form of exorcism, which included not only incantations and ritual practices but also the application of salves, a kind of homeopathic practice that approaches nearer to our contemporary understanding of effective medical care.

Some of the best-known examples of the use of music for prophecy and exorcism appear in the Hebrew Bible, in the stories of Kings Saul and David in 1 Samuel. This text relates how the elders of Israel came to the aging judge Samuel and demanded that he set a king over them, since his sons had not followed him in becoming honorable men. Samuel related their request in prayer to Yahweh, who answered that a human king would not be good for them, since God is their king; but they persisted, so Yahweh soon advised Samuel on how to find Saul and told him to

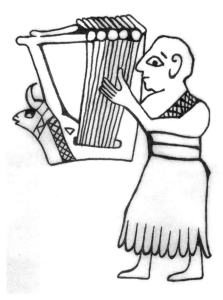

Fig. 17. *Musician Playing a Bull-Shaped Lyre. Based on a detail from the Royal Standard of Ur, ca. 26th century BCE. British Museum, London, U.K. Drawing by Alexander Price.*

anoint Saul as king of Israel.

 After encountering Saul and honoring him as the guest of honor at a feast in 1 Sam. 9, in the next chapter Samuel anointed Saul as king of Yahweh's people. He told Saul what would happen to him later that day:

> ...go on to the Hill of God, where the Philistine prefects reside. There, as you enter the town, you will encounter a band of prophets coming down from the shrine, preceded by lyres, timbrels, flutes, and harps, and they will be prophesying. The spirit of [Yahweh] will grip you, and you will prophesy along with them; you will become another man."

...As [Saul] turned around to leave Samuel, God gave him another heart; and all those signs were fulfilled that same day.[103]

(10:5-6,9)

Ensuing chapters tell of Israel's military exploits under king Saul. Eventually, Saul failed to obey the orders of Yahweh and was removed as king. Samuel anointed the young shepherd David, but this time the spirit of Yahweh appears to have seized him instantly, without the need for an intermediary band of musical prophets. At the same time the spirit seized David, it departed from Saul.

Now the spirit of [Yahweh] had departed from Saul, and an evil spirit from [Yahweh] began to terrify him. Saul's courtiers said to him, "An evil spirit of God is terrifying you. Let our lord give the order [and] the couriers in attendance on you will look for someone who is skilled at playing the lyre; whenever the evil spirit of God comes over you, he will play it and you will feel better. (16:14-16)

The courtiers sent for David, who was renowned for his skill with the lyre.

So David came to Saul and entered his service; [Saul] took a strong liking to him and made him one of his arms-bearers... Whenever the [evil] spirit of God came upon Saul, David would take the lyre and play it; Saul would find relief and feel better, and the evil spirit would leave him. (16:21-23)

The association between music and the spirit world is certainly not restricted to the ancient Near East, but is also a regular feature of shamanism, as expressed for example in the following exchange between anthropologist Jeremy Narby and Ashaninca shaman Don Carlos Perez:

> "I know that any living soul, or any dead one, is like those radio waves flying around in the air."
>
> "Where?"
>
> "In the air. That means that you do not see them, but they are there, like radio waves. Once you turn on the radio, you can pick them up. It's like that with souls; with ayahuasca and tobacco, you can see them and hear them."
>
> "And why is it that when one listens to the ayahuasquero singing, one hears music like one has never heard before, such beautiful music?"
>
> "Well, it attracts the spirits, and as I have always said, if one thinks about it closely... [long silence]. It's like a tape recorder, you put it there, you turn it on, and already it starts singing: hum, hum, hum, hum, hum. You start singing along with it, and once you sing, you understand them. You can follow their music because you have heard their voice..."[104]

In many South American shamanic traditions, the shaman's powers are said to derive from the songs that are taught to him by the spirits in such a way. And, of course, drumming and ecstatic dance are among the most readily recognizable features of shamanic practice.

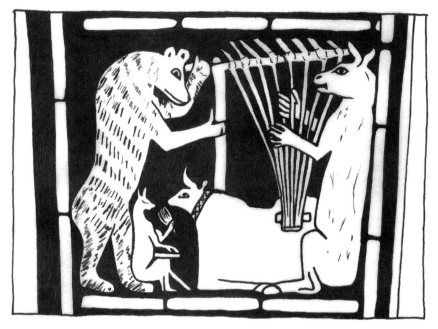

Fig. 18. *Animal Orchestra with a Bull-Shaped Lyre. Drawing based on a detail from the front panel of a bull-shaped lyre, from the tomb of Queen Pu-abi, 27th century BCE. University of Pennsylvania Museum of Archaeology and Anthropology, Philadelphia, Pennsylvania.*

The use of the lyre for divination, healing and prophecy was widespread in the ancient Near East, and is well attested in Greco-Roman religion.[105] The lyre itself (outside of Israel) was considered to be divine and thus a fitting recipient of offerings and sacrifices. The use of the divinized lyre can be traced at least as far back as the UR III period (ca. 2100 BCE) in ancient Sumer, to the court of King Gudea of Lagash. From there its use continued in Mesopotamia and spread to Ugarit, Cyprus, Israel, Greece and elsewhere in the Near East and Mediterranean. Some stunning examples of the Mesopotamian lyre were recovered from the tomb of Queen

Pu-abi of Ur, dated to ca. 2685 BCE, where the instruments took the shape of a stylized bull.

Mesopotamia had a special reverence for stringed instruments, particularly the harp and lyre, and shared with Greece a seven-note scale arranged around a central string. John C. Franklin connects this seven-note scale with a wider pattern of ancient mystical associations with the number seven, observing that:

> ...[T]he myth of the Seven Against Thebes echoes the foundation of Babylon by seven gods who must battle and defeat seven demons to establish the city, and by extension the cosmos. Aristotle attests that the Pythagoreans took the seven strings of the lyre, and the seven heroes of the seven Theban gates, the seven Pleiades, and so on, as parallel manifestations of some causative force inherent in the number seven; and here we should note that the Seven Gods of Babylonian tradition were also identified with the Pleiades.[106]

Similar to the seven-note musical system, the "Chaldean" (Babylonian) ordering of the planets, according to Greek astrologers, counted seven planets with the Sun at the center: Saturn, Jupiter, Mars, Sun, Venus, Mercury, Moon (with the moon seen as closest to the Earth and Saturn as furthest).[107]

Ancient Greeks believed that the human soul had its origin in the stars, and that it traveled down the path of the planets to reach Earth and had to travel back up the same way to return to its eternal home. The path of the seven

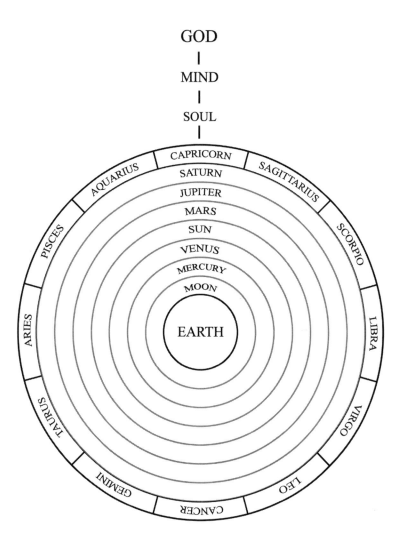

Fig. 19. *Ancient Greek cosmos. Drawing by Alexander Price.*

planets was conceived as a ladder for the soul's ascent, a journey that was central to the pagan Mysteries. The 3rd century Christian Father Origen related that:

> These things [i.e. celestial ascent] are intimated in the doctrine of the Persians and their Mysteries of Mithras. They have a symbol of the two celestial revolutions, that of the fixed stars and that assigned to the planets, and of the road of the soul through and out of them [i.e. the revolutions]. The symbol is this: a seven-gated ladder with an eighth at the top.[108]

The concept of *harmonia*, the Harmony of the Spheres, had originated in Greece in the teachings of Pythagoras, who was traditionally said to have been a student of "Zoroaster the Chaldean." The Pythagorean connection to the Near East has traditionally been dismissed as fanciful, but more recent scholarship has shown that there are compelling reasons to believe that Pythagoras was in close contact with a source of authentic Near Eastern teachings – specifically, the Zoroastrian priesthood in Babylon, who would have been in a position to transmit both Persian and Mesopotamian wisdom to the Greek sage.[109] (Note that previous chapters have focused on an earlier period of Mesopotamian culture, prior to the rise to prominence of the war-god Marduk and the composition of the *Enuma Elish*).

11

The Zoroastrian Dawn

The idea that time has a beginning and will have an end is generally credited to the 2nd millennium BCE Iranian prophet Zoroaster. Scholars have long debated the extent to which Zoroastrianism influenced Jewish and Christian apocalypticism, but the contribution seems to have been significant.

Zoroaster is believed to have lived about 1500 – 1200 BCE, although the dating of his life has always been notoriously problematic.[110] The Zoroastrian religion itself was largely a reformation of the much older pagan Iranian religion, which descended ultimately from a common ancestor of the Indian Vedic religion (the most ancient element of what we would today call Hinduism). The two faiths thus shared in common many deities, beliefs and religious practices, as part of an extensive common linguistic and cultural heritage. In the ancient Iranian worldview, the universe was held to be contained within an encircling sky made

of stone; the lower part of this was filled with water, on top of which sat the solid, circular earth. This flat earth was bordered by a great mountain range, and in the center of the earth was the Peak of Hara (Mount Meru in Hinduism and Buddhism). This mountain – which was believed to behave as a plant, with roots and life – grew up into the highest heavens, and all the celestial bodies were believed to circle around it, with day and night being caused by the Sun retiring through a western window to the other side of the mountain, to emerge again in the morning from a window in the east. All of the waters of the Earth were believed to ascend through the center of Hara and emerge from the top in a great river (akin to the Ganges) which descended to fill an ocean at the base of the mountain. The deity Mithra was said to live on the highest peak of Hara, and once the religion had developed a doctrine of the soul's ascension, this journey was said to commence from the summit of Hara – a vision which shares much in common with contemporary Tibetan Buddhist cosmology. [111]

In Iranian pagan belief, when the world was first created, it had three unique occupants: a Tree, a Bull and a Man. There was no movement, but the Sun hung motionless directly overhead, and the Bull and the Man stood quietly on opposite sides of the land, with the Tree in the middle. Then, the gods performed a threefold sacrifice, bringing motion and life to existence. From the sacrifice of the Tree – which contained the seeds of all plants – proceeded all vegetation on Earth. From the sacrifice of the Bull came all animals, and from the sacrifice of the Man came all humanity. The first of the three sacrifices, that of the Tree, set the pattern for those that followed, as it was the seed of the Bull (i.e., semen)

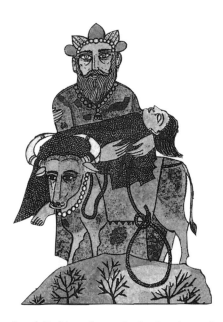

Fig. 20. *The Indo-Iranian deity Yama bears the dead to the underworld on the back of a bull. Contemporary.* © 2007 Hinduism Today *(http://www.hinduismtoday.com), licensed under Creative Commons License.*

that was brought up to the Moon, purified, and returned to Earth to grow into cattle and all other animals, and likewise the seed of Man that was brought up into the sun to be purified, then returned to Earth and grew up from the ground as the first human couple, man and woman. Furthermore, that the sacrifice of the Tree came first emphasized the fact that both men and animals depend on plant life for their survival. The final creation was of "fire itself, which, though visible and perceptible in its own right, was also considered to pervade the other six [creations: sky, water, earth, plants, cattle, and humanity], being 'distributed in all.'"[112]

The primordial sacrifices that brought the multiplicity of life into being were repeated in the sacrifices and rituals of

141

the prehistoric Iranian priests. In this way their ceremonies participated in the daily renewal of life, and were viewed as a necessary element of the universal order.

These religious beliefs and practices pre-dated the birth of Zoroaster, having their roots in prehistoric Indo-Iranian culture. Zoroaster himself was raised to become a priest in the Iranian faith, a training process that began at the tender age of seven. Traditional accounts say that he left home at the age of twenty, to pursue a nomadic life of spiritual seeking, which culminated in a mystical vision at the age of thirty. This took place at a Spring festival, at dawn, as Zoroaster waded into a river to draw water for the *haoma*-ceremony. As he returned to the bank with the water, he "saw standing on the bank a shining being clad in a garment like light itself, who, tradition says, revealed himself as Vohu Manah, Good Intention. He brought Zoroaster into the presence of Ahura Mazda and the other five immortals... And it was at that moment that spiritual enlightenment came to him."[112]

The new understanding of the religion that came to Zoroaster was based on the fundamental dualism between the spirits of good and evil. These, he said, were the original forces that stood prior to creation, equal in power but in moral opposition. Ahura Mazda (Middle Iranian, *Ohrmazd*), "Lord Wisdom," the spirit of righteousness and light, was the only deity worthy of worship; Angra Mainyu (MI, *Ahriman*) was the Hostile Spirit, the spirit of evil and darkness. As related in the *Yasna*:

> Now these two spirits, which are twins, revealed themselves at first in a vision. Their two ways of thinking, speaking and acting were the better and

the bad. – Between these two (ways) the wise choose rightly, fools not so. – And then when these two spirits first met, they created both life and not-life, and that there should be at the last the worst existence for the followers of the *Drug* [wrongdoing], but, for the followers of *Asha* [righteousness], the best dwelling. Of the two spirits, the one who follows the Drug chose doing the worst things, the Most Bounteous Spirit [Ahura Mazda]... chose asha, and (so do) they who will willingly come with true actions to meet Ahura Mazda.[113]

In Zoroaster's vision, after death the souls of the righteous ascended to join Ahura Mazda and the lesser deities of light in the heavens, a realm of bounteous joy, while the souls of the evildoers would descend to join Angra Mainyu and suffer in the underworld.

The struggle between the spirits of Good and Evil was seen as taking place within a unique period of time. In its original, perfect state, the creation did not inhabit time in the way it does now, but stood outside it in eternity; once the primordial sacrifice brought motion to the universe, then the period of time began. Within this limited experience of time, the spirits of Good and Evil (light and darkness) struggle with one another. Just as time had a beginning, it will have an end: when the Spirit of Good finally destroys the Spirit of Evil once and for all, then time will end and creation will return to its initial pristine state of peace and happiness in eternity. This eschatological event was called the *Frashokereti* (Pahlavi, *Frashegird*), the "Rehabilitation."

Zoroaster furthermore taught of the resurrection of

the dead, of an individual judgment in the grave and a Final Judgment that would come at the end of time, when the *Saoshyant* would appear to destroy the Spirit of Evil. While the latter was certainly viewed by Zoroaster's followers as a messianic figure, Zoroaster himself seems to have used the word *saoshyant* more generally, to refer to the just leaders who would follow him, as well as in reference to himself and all who followed the way of righteousness.

Pagan Iranians believed that the souls of the righteous dead ascended to heaven, where their physical body was immediately resurrected and their soul joined with it in paradise. In order to reach heaven, they had to pass over a perilous bridge called the *Chinvato Peretu*; the souls of those who did not merit paradise fell from the bridge into the dark netherworld below. Zoroaster retained much of this system, but taught that the Resurrection would occur only at the end of time, and that the reward or punishment that the soul received immediately after death was in spirit only and (like the temporal period of Good and Evil itself) was only temporary, a small taste of the eternal life that awaited after the Final Judgment.

At the time of the Final Judgment, all souls will have to walk through a river of molten metal, which to the righteous will feel like passing through warm milk, but to wrongdoers will feel like being made of flesh and passing through molten metal. It's unclear whether Zoroaster believed that the river would destroy the evildoers themselves, or destroy only the evil inside them. A belief held by Zoroastrians at least since the Sassanid Empire (ca. 800 CE) is that the river will be for purification, and everyone will emerge clean on the other side and be able to participate in the life of joy in the

eternal life.

Just as, in the beginning, time began with the sacrifice of a bull, so too will it end the same way. The Saoshyant will sacrifice a bull and all the righteous will participate in the sacred feast, which will render their resurrected bodies immortal and restore the earth to a state of eternal perfection. In the same way that the sacrifice of the primordial bull was commemorated and continued through the sacrifices and rituals of the priests, this eschatological bull-slaughter was prefigured by an annual festival, called *No Roz*, "New Day," which was said to renew the world and cleanse it of the sins that had accumulated over the previous year. Zoroastrian scholar Mary Boyce related:

> Rapithwina, to whom the festival is immediately dedicated, is, as the divinity of noonday, the lord of ideal time, that of the perfect primeval state, of the completed resurrection, and of Frashokereti; and each year when he returns to the earth in spring this is a foreshadowing of the final triumph of good. As Zadspram says: 'The making of Frashegird is like the year, in which at springtimes the trees have been made to blossom... Like the resurrection of the dead, new leaves are made to shoot from dry plants and trees, and springtimes are made to blossom.'[114]

Zoroaster did not attribute a chronology to his apocalyptic vision. This remained for the Zurvanite sect that emerged after the Persian conquest of Babylon, as a syncretism of Zoroastrian religion with the fatalist tradition of Mesopotamian celestial omens.

12

Mithras the Rejuvenator

The Mysteries of Mithras was a Greco-Roman religious sect that claimed to preserve the esoteric mystical secrets of the Persians. There has been extensive debate among contemporary scholars whether the Mithraic Mysteries were authentically Near Eastern or whether the cult was a wholly Greco-Roman invention. I believe the truth lies somewhere in the middle, but the issue is far from settled.

At the center of the Mithraic Mysteries was the climactic image of the deity Mithras slaying a bull, a scene known as the *tauroctony*. This was often depicted in the center of a zodiac circle, and the scene itself involves figures that can themselves be identified as constellations: the dog (Canis Minor) and snake (Hydra), shown lapping at the blood that streams forth from the bull's mortal wound, the scorpion (Scorpius) that attacks the dying bull's testicles, and often a raven (Corvus) that watches on. This has led some theorists to identify the bull itself with Taurus.[115]

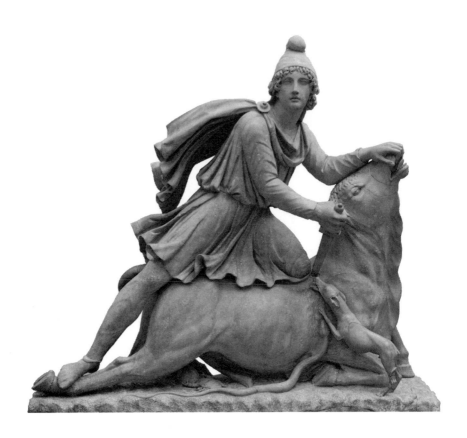

Fig. 21. *The tauroctony, the climactic scene of the Mithraic Mysteries. Rome, 2nd century CE. British Museum, London, U.K. Photograph © 2006 Marie-Lan Nguyen/Wikimedia Commons.*

A contemporary scholar of Mithraism, Roger Beck, originally followed the astrological interpretation of the scene, but later refined his theory:

> Astronomy and astrology, I am increasingly persuaded, are medium, not message. In other words, they convey esoteric truths about Mithras and a Mithras-dominated universe, but those esoteric truths are not themselves, at least for the most part, astronomical or astrological. So the astral symbolism in which the monuments abound seems to me to be a sort of idiom, a special language in which the representations of the mysteries are communicated to the initiates.[116]

Based on the broad picture that I see emerging in the present study, I would speculate that the climactic image of the bull slaying in the Mithraic Mysteries might represent the soul's liberation from the physical body.

In his *Commentary on the Dream of Scipio*, Macrobius remarked:

> [T]o our terrestrial bodies the soul is drawn downwards, and here it is believed to be dead while it is shut up in a perishable region and the abode of mortality... In truth... when [the soul] has rid itself completely of all taint of evil and has deserved to be sublimated, it again leaves the body and, fully recovering its former state, returns to the splendor of everlasting life.[117]

This is the moment I see captured in the tauroctony. It is emblematic of *regeneration*, in a Zoroastrian sense.

> The two great cosmocrators, Isis and Mithras, were personally involved in the 'transport' of the human worshipper through the astral bodies, the powers of 'elements'... Each deity was a personal savior, the creator of a spiritual regeneration. Just as Lucius is told by the Isiac Father Mithras how the goddess restores her devotees after a new birth to run the race of fresh salvation that is set before them... so in a graffito on a wall of the Santa Prisca Mithraeum an otherwise unknown worshipper of the Iranian god records that on 20 November (the year being 202 A.C.) he was 'born again at daylight'...[118]

The ascent through the heavenly spheres was believed to be accomplished in a mystical way by initiates through sound and specifically the intonation of the seven vowels. Godwin relates that:

> ...Eusebius [wrote] that it was with the seven vowels that the Jews sought to express the name of God which cannot be spoken, but that they reduced these to four for the use of the multitude. He draws a parallel with a saying he remembers from one of the Wise Men of Greece (who may well be Porphyry again): "The Seven Vowels celebrate me, the great imperishable God, indefatigable Father of all. I am the imperishable lyre, having tuned the lyric songs of the celestial vortex." This is a formulation of the

beautiful doctrine of astral paganism, according to which the Sun is the leader of the choir of planets, and Apollo's lyre a symbol of the harmony of the spheres.[119]

As stated by Macrobius: "[I]n the seven strings of Apollo's lyre we may see a reference to the movements of the seven celestial spheres, which nature has placed under the control of the sun."[120]

The seven planets were believed to emit a tone that was inaudible to the senses since it was sounded from the astral plane. "Also," Godwin adds, "the sound of whistling, in the Gnostic and Chaldean oracular literature, is associated with the descent of the soul from the higher spheres into the body...."[121] And from Manfred Clauss: "The initiand ascended higher and higher up the ladder of the planets into the sphere of the fixed stars with the aid of these varied vowel-sequences, sometimes spoken naturally, sometimes intoned."[122] A vowel-ladder is depicted visually on a gem reproduced by Manfred Clauss, with the seven Greek vowels shown ascending the ladder; from bottom to top: Long O, Y, O, I, Long E, E and A. The obverse side of the gem depicts an eagle standing on an arrow.

The intoned vowel-sequences were "combined in such a way that they formed no known word and gave no immediate sense."[123] The following is a representative example from a Mithraic prayer preserved in the Greek magical papyri:

...I invoke the immortal names, living and honored, which never pass into mortal nature and are not declared in articulate speech by human tongue or mortal sound: ĒEŌ OĒEŌ IŌŌ OĒ ĒEŌ ĒEŌ OĒ EŌ IŌŌ OĒĒE ŌĒE ŌOĒ IĒ ĒŌ OŌ OĒ IEŌ OĒ ŌOĒ IEŌ OĒ IEEŌ EĒ IŌ OĒ IOĒ ŌĒŌ EOĒ OEŌ ŌIĒ ŌIĒ EŌ OI III ĒOĒ ŌYĒ ĒŌOĒE EŌ ĒIA AĒA EĒA / ĒEEĒ EEĒ EEĒ IEŌ ĒEŌ OĒEEOĒ ĒEŌ ĒYŌ OĒ EIŌ ĒŌ ŌĒ ŌĒ EE OOO YIŌĒ.[124]

I imagine this sequence, passionately intoned, must have sounded much like it reads.

Of equal significance, in my estimation, are the references to breathing techniques in this particular prayer. Immediately after the opening invocation, the initiate is instructed:

Draw in breath from the rays, drawing up 3 times as much as you can, and you will see yourself being lifted up and ascending to the height, so that you seem to be in midair.

While experiencing a series of visions, the initiate is instructed how to respond to the supernatural entities s/he encounters; and then is directed to "stand still and at once draw breath from the divine into yourself..." Then, a bit later, s/he is told to "look intently, and make a long bellowing sound, like a horn, releasing all your breath and straining your sides..." And then again, shortly thereafter, "...at once / make a long bellowing sound, straining your belly, that you may excite the five senses; bellow long until out of breath..."

This is evocative of shamanic breathing techniques that are often used to induce an altered state of consciousness. Such techniques are not only practiced by shamans, but can be found among mystics of all persuasions, including Islam (Sufism), Buddhism, Judaism (Kabbalah), and of course in the well-known Hindu practice of kundalini yoga.

Epilogue

The Return of the King

In his book, *Secrets of Mayan Science/Religion*, Hunbatz Men provides a revealing interpretation of the myth of Quetzalcoatl (Mayan *Kukulcan*).

From this moment on, I would like you to realize that we are all Quetzalcoatl or Kukulcan. We need only to develop our faculties of consciousness to fully realize that status... To be Quetzalcoatl or Kukulcan is to know the seven forces that govern our body – not only to know them, but also use them and understand their intimate relationship with natural and cosmic laws. We must comprehend the long and short cycles and the solar laws that sustain our lives. We must know how to die, and how to be born.[125]

The idea is certainly not unique to Mayan religion. In a talk given in 1973, the universalist Hindu guru Osho Rajneesh advised his disciples:

> Buddha, a Krishna or a Christ, is not an ideal for you... Buddhahood is the ideal, not Buddha. Christhood is the ideal, not Jesus. Buddhahood is different from Gautam Buddha; Christhood is different from Jesus. Jesus is only one of the Christs. You can become a Christ, but you can never become a Jesus. You can become a Buddha, but you can never become Gautam. Gautam became a Buddha and you can become a Buddha.[126]

The inimitable Lama Yeshe has a book, *Becoming the Compassion Buddha*, that explains the idea within the tantric tradition of Tibetan Buddhism.[127] The Sufis, similarly, have a saying that the ways to God are as many as the breaths of mankind.

Hunbatz Men goes on to explain how the "Plumed Serpent," Quetzalcoatl, is none other than the serpent-power that resides at the base of the spine and is known to Hindus as *kundalini*. This is awakened and directed through specific breathing exercises that allow the initiate to utilize the energy of the universe for healing and rejuvenation.

From this inner, esoteric perspective, the fragments of Aztec myth preserved in *Tira de la Peregrinacion* take on a very personal and mystical meaning. Aztlan, the "Place of Wings," is the original home of the soul (the hummingbird Tetzauhteotl/Huitzilopochtli), which enters the womb, the "Cave of Imminent Departure." (As mentioned in the first

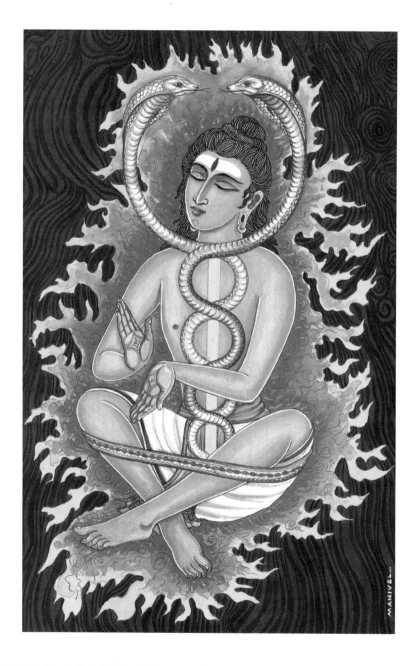

Fig. 22. *Kundalini Siddha.* © 2007 *Hinduism Today (http://www.hinduismtoday.com),*
licensed under Creative Commons License.

chapter, the Native American people say they emerged into this world directly from the underworld).

The last thing Grandfather Martin showed me on my visit to the Hopi Reservation was a unique painting of the Seven Caves, where the Place of Emergence was depicted as a heart. Inside the heart was an eagle with a snake in its mouth perched on a cactus, which in Aztec mythology was the sign the wandering tribe was told they'd see when they reached their destination – the place they would find the Great Spirit waiting for them, at the Center of the Universe.

The theme of *wandering* (Skt. *samsara*) is an element of many religious stories. The ancient Jews wandered in the wilderness for forty years before being delivered to their Promised Land – Jerusalem, the "City of Peace." The first Muslims migrated from Mecca to Medina and initiated the annual pilgrimage to the Ka'aba (related to Arabic *kalb*, heart) which continues to this day. There are many ways to symbolize the journey, but each generation has to make it anew using a vocabulary that's relevant to them.

The Hopis have a prophecy that at the end of the present world cycle, a vast number of people will converge on Hopi land. There, at the heart and center of the world, spiritual leaders will come together to draw up a new Plan of Life for the coming world, a plan based on love, mutual respect, and universal brotherhood. All the world's religions, Grandfather Martin stressed, are One. They spring from one Source, and lead to one Goal.

Appendix

Select List of Additional Resources

Osmanli Naksibendi Sufi Center

http://www.naksibendi.org

A traditional Sufi dergah in the Catskill Mountains of New York. Under the guidance of Shaykh Mevlana Nazim al-Hakkani; group led by Shaykh Abdul Kerim al-Kibrisi, a direct descendant of Rumi and the Holy Prophet Muhammad.

Kriya Yoga Institute

http://www.kriya.org

"Kriya Yoga is a golden opportunity to reach higher states of consciousness and change your life." Lineage through Sri Yukteswar Giri and Mahavatar Babaji. Current head: Paramahamsa Prajnanananda.

Mahakranti Mystery School

http://www.mahakranti.org

"An esoteric college offering a connection to a distinguished lineage of enlightened Masters." Group founded by the author.

Rebirthing Breathwork International

http://www.rebirthingbreathwork.com

"Rebirthing-Breathwork, aka Intuitive Energy Breathing or Conscious Energy Breathing, is the ability to breathe Energy as well as air... Rebirthing also means to unravel the birth-death cycle and to incorporate the body and mind into the conscious Life of the Eternal Spirit." Group initiated by Herakhan Babaji, directed by Leonard Orr.

Notes

1. C.f. Diamond (1998).

2. Quoted in Herman, 2003.

3. For the early history of Hopi contact with the Spanish, see: Courlander (1971); Weber (1992).

4. Kaufman (2001). C.f. Coe & Koontz (2008); Herrera (1999). Hegmon (2000), esp. Ch. 14, discusses the spread of the Hopic language branch of Uto-Aztecan from the southern California region. The Wikipedia entry on this difficult subject should be approached with especial caution.

5. Herrera (1999).

6. James (2000), James (2002).

7. My primary sources for this subject are Coe (2005) and Coe & Koontz (2008).

8. Bierhorst (1992), p. 147.

9. Johansson K., 2007.

10. Coe & Koontz (2008), p. 154.

11. Bierhorst (1992); Nicholson (2001).

12. Coe & Koontz (2008), p. 225.

13. Nicholson (2001), p. 37.

14. ibid., p. 188.

15. Coe (2005), p. 61.

16. ibid., p. 64.

17. Peterson (1990), p. 11.

18. Coe (2005), p. 63.

19. Peterson (1990), p. 13.

20. Men (in press).

21. Yaxkin (1998).

22. Kaanek' (1998).

23. Strous (2007).

24. Jimenez & Graeber (2001), p. 34.

25. Quoted in Jimenez & Graeber, ibid.

26. Quoted at Sitler (2009). Gonzalez's book is available from Yax Te' Books (http://www.yaxtebooks.com) and an English translation is forthcoming.

27. Parada (1997), recommended. The ancient Greeks, in general, seem not to have been concerned with what would happen beyond the advent of a new Golden Age, which they often anticipated with great sentiment.

28. Wilson (1864), p. 26.

29. Mahabharata 3.148.10-37; quoted in Gonzalez-Reimann (2002), Appendix B. I have reformatted this into paragraphs for space constraints, emphasized the names of the four yugas, and modified some of the transliterations for readers unfamiliar with Sanskrit pronunciation.

30. Yukteswar (1972).

31. Rochberg (1998).

32. Rogers (1998b).

33. Among these four, the identification of the Water Bearer is more tentative. C.f. Rogers (1998a).

34. J. Laskar et al., quoted in Strous (2007).

35. Subramuniyaswami (1998)

36. Godwin (1994).

37. Godwin (1990).

38. Blavatsky (1991), p. 446-447.

39. Besant (1922).

40. Godwin (1996), pp. 22-23.

41. Reynolds (2000).

42. Kaanek' (1998).

43. Scott (2002), p. 53-54. 53fn74 provides a wealth of information for anyone interested in pursuing the subject.

44. Genesis 37:9-10. NJPS translation.

45. See, e.g., Zohar, Vayechi; Gikatilla (1994).

46. Godwin (1994).

47. ibid., p. 4.

48. ibid., pp. 82-83.

49. Higgins (1833), p. 149.

50. ibid., p. 240.

51. Blavatsky (1877), p. 347.

52. Blavatsky (1986), p. 225fn. The original comment, given in the previous volume (vol. 8, p. 203) of her Collected Works, was in French: "Chaque acte du Jésus du Nouveau Testament, chaque parole qu'on lui attribue, chaque évènement qu'on lui rapporte pendant les trois années de la mission qu'on lui fait accomplir, repose sur le programme du Cycle de l'Initiation, cycle basé lui-même sur la précession des Équinoxes et les signes du Zodiaque."

53. Blavatsky (1888), p. 314.

54. ibid., p. 642.

55. Gary and Malokti (2001)

56. C.f. Harris (1968); Kuper (2005). Harris, p. 431, notes that "Moral relativism was an important side effect of the critique of 19th century

evolution." The interesting subject of moral relativism is particularly relevant to international politics, where there is often a tension between local community values and human rights.

57. See Rossano (2006) for discussion and references.

58. Freud (1939); Assmann (1997).

59. Assmann (1997), p. 100.

60. Note however that in the biblical narrative, after abdicating the throne and prior to the Exodus, Moses is said to have apprenticed under Jethro, the Priest of Midian (modern-day Hijaz). Coogan (2001), pp. 105ff.

61. Critics of Diamond have argued against what they perceive as his "environmental determinism" – that is, his emphasis on geographical influences on social evolution to the neglect of all others. They believe his theories fail to account for the multiple complex causes that contribute to change in human societies. The controversy is not relevant here, however, where the point is simply that there is an apparent correlation between population size and political organization.

62. For discussion of ancestor worship in ancient Egypt see Frankfort (1948), Ch. 7. For discussion of biblical ancestor worship and references through 1992, see Hallo, W.W. "Royal Ancestor Worship in the Biblical World." In Fishbane & Tov (1992).

63. Bloch, M. "Ancestors." In Barnard & Spencer (1996).

64. Boyce (1984), pp. 9-10, where the editor was describing the practice among ancient Iranians.

65. Bloch, op cit.

66. Allsen (2006).

67. ibid, p. 150; with references.

68. E.g. Green, A. "Myths in Mesopotamian Art." In Finkel & Geller (1997).

69. Psalm 23, New King James Version.

70. Genesis 29; Exodus 2. That Moses works as a shepherd is

made explicit in Ex. 3:1, "Now Moses was tending the flock of Jethro his father-in-law, the priest of Midian, and he led the flock to the far side of the desert and came to Horeb..."

71. See also Psalm 49.

72. On the use of the "pit" or "valley" as a metaphor for death and sheol, see Johnston (2002).

73. Westenholz (2004).

74. Rev. 7:16-17, NASB translation.

75. Westenholz (2004), p. 281. This work has been my primary source for the section on the Divine Shepherd.

76. In Bromiley, ed. (1969), p. 486.

77. Griffiths (1980).

78. In 2009, I had the opportunity to visit the Tibetan community of Tashi Jong in India, which had been in the news a couple years earlier for its controversial decision to mummify a beloved guru, Yogi Amtrin. I was puzzled by this unconventional decision – mummification is exceedingly rare in Buddhism – until I connected it with their practice of murti worship, and understood that they were turning the yogi into a particularly powerful kind of statue. A major difference between this and the Egyptian practice is that the latter was for the benefit of the deceased, while the Tibetan Yogi was preserved as an object of veneration.

79. Assmann (2005), p. 31.

80. Lommel (1967). Quoted in McKenna & McKenna (1975).

81. Assmann (2001), p. 153, observes that the practice of shamanism is "entirely absent" from ancient Egypt. Although I have not seen any studies on the subject, shamanism in general appears to be an almost exclusively tribal practice that does not survive the formation of the state and state religion; yet remnants of its former practice may persist.

82. Pinch (2002), p. 15.

83. Eyre (2002), pp. 44-45; with references. Egyptian transliterations omitted here.

84. Allen & Manuelian (2005), p. 107.

85. Assmann (2005), p. 68.

86. Faulkner (1969).

87. In a footnote, Faulkner refers the reader to Fox (1951), p. 56, "[f]or a group embodying this notion, but with a leopard instead of a bull."

88. Assmann (2005), pp. 200ff.

89. Livingstone (2007), pp.116ff, especially pp. 136-141.

90. Foster (2005), p. 439.

91. Sanders (1999), p. 76.

92. ibid., p. 448-449.

93. Translated and discussed in George (1999), pp. 175-195.

94. Notably Dalley (1991), Dalley (1994).

95. I.29-30, 45-48. All quotes from the Gilgamesh Epic are from George (1999) unless otherwise indicated.

96. George has "goddess of weddings," as he does not connect this scene with the *hieros gamos*.

97. George (1999), IX.138, here gives "path of the Sun God," but provides a detailed discussion in the critical edition, George (2003), pp. 492ff.

98. I VAT 8917, obv. 11. Livingstone (2007), pp. 95, 103, 111. See also p. 181 for discussion of the association of Dumuzi with the date palm in CBS 6060 and dupls.

99. C.f. Foster, "Gilgamesh: Sex, Love and the Ascent of Knowledge." In Maier (1997).

100. West (1997). On Hercules et al., pp. 462, 466ff. In general, see also Burkert (1992).

101. George (2003), p. 68; p. 28ff.

102. Lenzi (2008), with discussion and references.

103. NJPS translation, though I substitute here their alternate translation of "prophesize" over "speak in ecstasy."

104. Narby (1998).

105. My source for this subject is the work of J.C. Franklin, especially Franklin (2006a) and Franklin (2006b). Prof. Franklin has conveniently made much of his published work available online via his website at http://www.kingmixers.com.

106. Franklin (2006b), p. 2.

107. Beck (1988), p. 4.

108. Quoted in Beck (1988), p. 73.

109. Kingsley (1990).

110. Boyce (1989), pp. 3 & 348. Kingsley (1990).

111. E.g. as revealed in the Kalachakra Initiation.

112. Boyce (1989), p. 140.

113. ibid., pp. 192-193.

114. ibid., p. 245.

115. Ulansey (1989).

116. Beck (2004), p. xxv.

117. Macrobius (1952), p. 137.

118. Witt, R.E. "Some Thoughts on Isis in Relation to Mithras." In Hinnels (1975), p. 489.

119. Godwin (1991), p. 22.

120. Macrobius (1969), p. 135.

121. Godwin, op cit.., p. 24.

122. Clauss (2000), p. 107.

123. ibid.

124. Betz (1986), p. 50.

125. Men (1990), p. 109.

126. Osho (1998), p. 677.

127. Yeshe (2003).

Bibliography

Allen, James P. & Peter der Manuelian. (2005). *The Ancient Egyptian Pyramid Texts*. Atlanta: Society of Biblical Literature.

Allsen, Thomas T. (2006). *The Royal Hunt in Eurasian History*. Philadelphia: University of Pennsylvania Press.

Assmann, Jan. (1997). *Moses the Egyptian*. Cambridge: Harvard University Press.

———. (2001). *The Search for God in Ancient Egypt*. Ithaca: Cornell University Press.

———. (2005). *Death and Salvation in Ancient Egypt*. Ithaca: Cornell University Press.

Barnard, Alan, & Jonathan Spencer. (1996). *Encyclopedia of Social and Cultural Anthropology*. New York: Routledge.

Beck, Roger. (1988). *Planetary Gods and Planetary Orders in the Mysteries of Mithras*. Leiden: Brill.

———. (2004). *Beck on Mithraism* Aldershot, England: Ashgate Publishing.

Besant, Annie W. (1922). *Talks With a Class*. Chicago: Theosophical Press.

Betz, H.D. (1986). *The Greek Magical Papyri in Translation*. Chicago: University of Chicago Press.

Bierhorst, John, trans. (1992). *History and Mythology of the Aztecs: The Codex Chimalpopoca*. Tucson: University of Arizona Press.

Blavatsky, Helena P. (1877). *Isis Unveiled*. New York: J.W. Bouton.

———. (1888). *The Secret Doctrine*. London: Theosophical Publishing House.

———. (1986). *H. P. Blavatsky/Collected Writings*, Vol. 9. Wheaton: Theosophical Publishing House.

———. (1991). *H. P. Blavatsky/Collected Writings*, Vol. 4. Wheaton: Theosophical Publishing House.

———. (1995). *H. P. Blavatsky/Collected Writings*, Vol. 14. Wheaton: Theosophical Publishing House.

Boyce, Mary, ed. (1984). *Textual Sources for the Study of Zoroastrianism*. Manchester: Manchester University Press.

———. (1989). *A History of Zoroastrianism*, Vol. 1. Leiden: Brill.

Bromiley, Geoffrey W., ed. (1969). *Theological Dictionary of the New Testament*. Grand Rapids: William B. Eerdmans.

Burkert, Walter. (1992). *The Orientalizing Revolution*. Cambridge: Harvard University Press.

Clauss, Manfred. (2000). *The Roman Cult of Mithras*. New York: Routledge.

Coe, Michael D. (2005). *The Maya*. 7th ed. London: Thames & Hudson.

Coe, Michael D., & Rex Koontz. (2008). *Mexico*. London: Thames & Hudson.

Coogan, Michael D. (2001). *The Oxford History of the Biblical World*. Oxford: Oxford University Press.

Courlander, Harold. (1971). *The Fourth World of the Hopis*. New York: Crown Publishers.

Dalley, Stephanie. (1991) "Gilgamesh in the Arabian Nights," *Journal of the Royal Asiatic Society*, pp. 1-17.

————. (1994) "The Tale of Buluqiya and the Alexander Romance in Jewish and Sufi Mystical Circles," in J.C. Reeves, ed. *Tracing the Threads*. Atlanta: Scholars Press. pp. 239-69.

Diamond, Jared M. (1998). *Guns, Germs, and Steel*. New York: W.W. Norton & Co.

Eyre, Christopher. (2002). *The Cannibal Hymn*. Liverpool: Liverpool University Press.

Faulkner, Raymond O. (1969). *The Ancient Egyptian Pyramid Texts*. Oxford: Clarendon Press.

Finkel, Irving L., & Markham J. Geller. (1997). *Sumerian Gods and Their Representations*. Groningen: STYX Publications.

Fishbane, Michael A., & Emanuel Tov. (1992). *Sha'arei Talmon*. Winona Lake: Eisenbrauns.

Foster, Benjamin R. (2005). *Before the Muses*. Bethesda: CDL Press.

Fox, Penelope. (1951). *Tutankhamun's Treasure*. London: Oxford University Press.

Frankfort, Henry. (1948). *Kingship and the Gods*. Chicago: University of Chicago Press.

Franklin, John C. (2006a). "Lyre Gods of the Bronze Age Musical Koine." *Journal of Ancient Near Eastern Religions*. 6:2, pp. 39–70.

————. (2006b). "The Wisdom of the Lyre: Soundings in Ancient Greece, Cyprus and the Near East." In E. Hickmann & R. Eichmann, eds., *Musikarchäologie im Kontext*. Rahden: Leidorf.

Freud, Sigmund. (1939). *Moses and Monotheism*. New York: Knopf.

Gary, Ken and Ekkehart Malotki. (2001). *Hopi Stories of Witchcraft, Shamanism, and Magic*. Lincoln: University of Nebraska Press.

George, Andrew R. (1999). *The Epic of Gilgamesh*. London: Allen Lane.

————. (2003). *The Babylonian Gilgamesh Epic*. Oxford: Oxford University Press.

Gikatilla, Joseph. (1994). *Gates of Light: Sha'are Orah*. Avi Weinstein, trans. Walnut Creek: Altamira Press.

Godwin, Joscelyn (1990). "The Hidden Hand - Part I: The Provocation of the Hydesville Phenomena." *Theosophical History*, 3:2, pp. 35-43.

———. (1991). *The Mystery of the Seven Vowels*. Grand Rapids: Phanes Press.

———. (1994) *The Theosophical Enlightenment*. Albany: SUNY Press.

———. (1996). *Arktos*. Kempton: Adventures Unlimited Press.

Gonzalez-Reimann, Luis. (2002). *The Mahābhārata and the Yugas*. New York: Peter Lang.

Griffiths, John G. (1980). *The Origins of Osiris and His Cult*. Leiden: Brill.

Harris, Marvin. (1968). *The Rise of Anthropological Theory*. New York: Crowell.

Hegmon, Michelle. (2000). *The Archaeology of Regional Interaction*. Boulder, University Press of Colorado.

Hermon, Douglas. (2003). *Geografia Indigena*. Towson University, Maryland, viewed 13 June 2009. <http://pages.townson.edu/dherman.hopi>.

Herrera, Fermin. (1999). "In Search of Aztlan." In Search of Aztlan, California, viewed September 18, 2009. <http://insearchofaztlan.com/herrera.html>.

Higgins, Godfrey. (1833). *Anacalypsis*. New York: J.W. Bouton.

Hinnells, John R. (1975). *Mithraic Studies*. Manchester: Manchester University Press.

Houlihan, Patrick F. (1996). *The Animal World of the Pharaohs*. London: Thames & Hudson.

James, Susan E. (2000). "Some Aspects of the Aztec Religion in the Hopi Kachina Cult." *Journal of the Southwest*. 42:4, pp. 897-926.

———. (2002). "Mimetic Rituals of Child Sacrifice in the Hopi Kachina Cult." *Journal of the Southwest*. 44:3, pp. 337–356.

Jiménez, Randall C., and Richard B. Gräeber. (2001). *The Aztec Calendar Handbook*. Saratoga, CA: Historical Science Publishing.

Johansson K., Patrick. (2007). "Tira de la Peregrinacion." *Arqueologia Mexicana*, no. 26.

Johnston, Philip. (2002). *Shades of Sheol*. Leicester, England: Apollos.

Kaanek, Gerardo Barrios. (1998). "Mayan Time, Prophecy and the Tzolk'in." Center of the Sun, Sedona, Arizona, viewed 7 October 2009. <http://www.kachina.net/~alunajoy/timekeeper.html>.

Kaufman, Terrence. (2001) "The History of the Nawa Language Group From the Earliest Times to the Sixteenth Century: Some Initial Results." Project for the Documentation of the Languages of Mesoamerica, University at Albany, New York. Viewed 18 September, 2009. <http://www.albany.edu/anthro/maldp/Nawa.pdf>.

Kingsley, Peter. (1990). "The Greek Origin of the Sixth-Century Dating of Zoroaster." *Bulletin of the Schools for Oriental and African Studies*, 53, pp. 245-265.

Kuper, Adam. (2005). *The Reinvention of Primitive Society*. London: Routledge.

Lenzi, Alan. (2008). *Secrecy and the Gods*. Helsinki: Neo-Assyrian Text Corpus Project.

Lesko, Leonard H. (1972). *The Ancient Egyptian Book of Two Ways*. Berkeley: University of California Press.

Livingstone, Alasdair. (2007). *Mystical and Mythological Explanatory Works of Assyrian and Babylonian Scholars*. Winona Lake: Eisenbrauns.

Lommel, Andreas. (1967). *The World of the Early Hunters*. London: Evelyn, Adams & Mackay.

Macrobius. (1952). *Commentary on the Dream of Scipio*, William H. Stahl, trans. New York: Columbia University Press.

———. (1969). *The Saturnalia*, P.V. Davies, trans. New York: Columbia University Press.

Maier, John R. (1997). *Gilgamesh: A Reader*. Wauconda: Bolchazy-Carducci Publishers.

McKenna, Dennis & Terence McKenna. (1975). *The Invisible Landscape*. New York: Seabury Press.

Men, Hunbatz. (1990). *Secrets of Mayan Science/Religion.* Santa Fe: Bear & Co.

———. (in press). *The 8 Calendars of the Maya: The Pleiadian Cycle and the Key to Destiny.* Rochester, VT: Bear & Co.

Narby, Jeremy. (1998). *The Cosmic Serpent: DNA and the Origins of Knowledge.* New York: Parcher/Putnam.

Nicholson, Henry B. (2001). *Topiltzin Quetzalcoatl.* Boulder, Colorado: University Press of Colorado.

Osho. (1998). *The Book of Secrets.* New York: St. Martin's Griffin.

Parada, Carlos. (1997). "The Ages of the World." Greek Mythology Link, Sweden, viewed 28 May 2009. <http://www.maicar.com>.

Parpola, Simo. (1993). "The Assyrian Tree of Life: Tracing the Origins of Jewish Monotheism and Greek Philosophy." *Journal of Near Eastern Studies,* 52:3, pp. 161-208.

———. (1997). *Assyrian Prophecies.* State Archives of Assyria 9. Helsinki University Press.

Peterson, Scott. (1990). *Native American Prophecies.* New York: Paragon House.

Pinch, Geraldine. (2002). *Handbook of Egyptian Mythology.* Santa Barbara: ABC-CLIO.

Reynolds, Alta. (2000). *Cycles: A View of Planet Earth from 4 Million BC to 15000 AD.* Hluhluwe, South Africa: Pondsview Publishing.

Rochberg, Francesca. (1998). *Babylonian Horoscopes.* Philadelphia: American Philosophical Society.

Rogers, John. (1998a). "Origins of the Ancient Constellations: I. The Mesopotamian Traditions." *Journal of the British Astronomical Association.* 108:1. p. 9-28.

———. (1998b) "Origins of the Ancient Constellations: II. The Mediterranean Traditions." *Journal of the British Astronomical Association.* 108:2. p. 79-89.

Rossano, Matthew J. (2006). "The Religious Mind and the Evolution of Religion." *Review of General Psychology*. 10:4, pp. 346-364.

Sanders, Seth L. (1999). *Writing, Ritual, and Apocalypse: Studies in the Theme of Ascent to Heaven in Ancient Mesopotamia and Second Temple Judaism*. Ph.D. dissertation, Johns Hopkins University.

Scott, James M. (2002). *Geography In Early Judaism and Christianity*. Cambridge: Cambridge University Press.

Sitler, Robert. (2009). "Mayan Perspectives on 2012." Stetson University, Florida, viewed 11 October 2009.
<http://www.stetson.edu/~rsitler/perspectives>.

Strous, Louis. (2007). "21 December 2012." Astronomy Answers. Astronomical Institute, Utrecht University, Netherlands, viewed 4 October 2009. <http://www.phys.uu.nl/~strous/AA/en/2012.html>.

Subramuniyaswami, Satguru Sivaya. (1998). *Lemurian Scrolls*. Kapaa, Hawaii: Himalayan Academy Press.

Ulansey, David. (1989). *The Origins of the Mithraic Mysteries*. New York: Oxford University Press.

Waters, Frank. (1963). *Book of the Hopi*. New York: Viking Press.

Weber, David J. (1992). *The Spanish Frontier in North America*. New Haven: Yale University Press.

West, Martin L. (1997). *The East Face of Helicon*. New York: Clarendon Press.

Westenholz, Joan G. (2004). "The Good Shepherd." In A. Panaino. Schools of Oriental Studies and the Development of Modern Historiography. Milan: Mimesis.

Wilson, Horace H. (1864). *The Vishnu Purana*, Vol. 1. London: Trubner & Co.

Yaxkin, Aluna J. (1998). "The Great Gift of the Calendars." Center of the Sun, Sedona, Arizona. Viewed 25 September 2009.
<http://www.kachina.net/~alunajoy/98june2.html>.

Yeshe, Thubten. (2003). *Becoming the Compassion Buddha*. Boston: Wisdom Publications.

Yukteswar, Swami Sri. (1972). *The Holy Science*. Los Angeles: Self-Realization Fellowship.

Get these fascinating books from your nearest bookstore or directly from: Adventures Unlimited Press
www.adventuresunlimitedpress.com

LOST CITIES & ANCIENT MYSTERIES OF AFRICA & ARABIA
by David Hatcher Childress

Childress continues his world-wide quest for lost cities and ancient mysteries. Join him as he discovers forbidden cities in the Empty Quarter of Arabia; "Atlantean" ruins in Egypt and the Kalahari desert; a mysterious, ancient empire in the Sahara; and more. This is the tale of an extraordinary life on the road: across war-torn countries, Childress searches for King Solomon's Mines, living dinosaurs, the Ark of the Covenant and the solutions to some of the fantastic mysteries of the past.

423 PAGES. 6x9 PAPERBACK. ILLUSTRATED. $14.95. CODE: AFA

LOST CITIES OF ATLANTIS, ANCIENT EUROPE & THE MEDITERRANEAN
by David Hatcher Childress

Childress takes the reader in search of sunken cities in the Mediterranean; across the Atlas Mountains in search of Atlantean ruins; to remote islands in search of megalithic ruins; to meet living legends and secret societies. From Ireland to Turkey, Morocco to Eastern Europe, and around the remote islands of the Mediterranean and Atlantic, Childress takes the reader on an astonishing quest for mankind's past. Ancient technology, cataclysms, megalithic construction, lost civilizations and devastating wars of the past are all explored in this book.

524 PAGES. 6x9 PAPERBACK. ILLUSTRATED. $16.95. CODE: MED

LOST CITIES OF CHINA, CENTRAL ASIA & INDIA
by David Hatcher Childress

Like a real life "Indiana Jones," maverick archaeologist David Childress takes the reader on an incredible adventure across some of the world's oldest and most remote countries in search of lost cities and ancient mysteries. Discover ancient cities in the Gobi Desert; hear fantastic tales of lost continents, vanished civilizations and secret societies bent on ruling the world; visit forgotten monasteries in forbidding snow-capped mountains with strange tunnels to mysterious subterranean cities! A unique combination of far-out exploration and practical travel advice, it will astound and delight the experienced traveler or the armchair voyager.

429 PAGES. 6x9 PAPERBACK. ILLUSTRATED. FOOTNOTES & BIBLIOGRAPHY. $14.95. CODE: CHI

LOST CITIES OF ANCIENT LEMURIA & THE PACIFIC
by David Hatcher Childress

Was there once a continent in the Pacific? Called Lemuria or Pacifica by geologists, Mu or Pan by the mystics, there is now ample mythological, geological and archaeological evidence to "prove" that an advanced and ancient civilization once lived in the central Pacific. Maverick archaeologist and explorer David Hatcher Childress combs the Indian Ocean, Australia and the Pacific in search of the surprising truth about mankind's past. Contains photos of the underwater city on Pohnpei; explanations on how the statues were levitated around Easter Island in a clockwise vortex movement; tales of disappearing islands; Egyptians in Australia; and more.

379 PAGES. 6x9 PAPERBACK. ILLUSTRATED. FOOTNOTES & BIBLIOGRAPHY. $14.95. CODE: LEM

A HITCHHIKER'S GUIDE TO ARMAGEDDON
by David Hatcher Childress
With wit and humor, popular Lost Cities author David Hatcher Childress takes us around the world and back in his trippy finalé to the Lost Cities series. He's off on an adventure in search of the apocalypse and end times. Childress hits the road from the fortress of Megiddo, the legendary citadel in northern Israel where Armageddon is prophesied to start. Hitchhiking around the world, Childress takes us from one adventure to another, to ancient cities in the deserts and the legends of worlds before our own. In the meantime, he becomes a cargo cult god on a remote island off New Guinea, gets dragged into the Kennedy Assassination by one of the "conspirators," investigates a strange power operating out of the Altai Mountains of Mongolia, and discovers how the Knights Templar and their off-shoots have driven the world toward an epic battle centered around Jerusalem and the Middle East.
320 PAGES. 6x9 PAPERBACK. ILLUSTRATED. BIBLIOGRAPHY. INDEX. $16.95. CODE: HGA

TECHNOLOGY OF THE GODS
The Incredible Sciences of the Ancients
by David Hatcher Childress
Childress looks at the technology that was allegedly used in Atlantis and the theory that the Great Pyramid of Egypt was originally a gigantic power station. He examines tales of ancient flight and the technology that it involved; how the ancients used electricity; megalithic building techniques; the use of crystal lenses and the fire from the gods; evidence of various high tech weapons in the past, including atomic weapons; ancient metallurgy and heavy machinery; the role of modern inventors such as Nikola Tesla in bringing ancient technology back into modern use; impossible artifacts; and more.
356 PAGES. 6x9 PAPERBACK. ILLUSTRATED. BIBLIOGRAPHY. $16.95. CODE: TGOD

VIMANA AIRCRAFT OF ANCIENT INDIA & ATLANTIS
by David Hatcher Childress, introduction by Ivan T. Sanderson
In this incredible volume on ancient India, authentic Indian texts such as the *Ramayana* and the *Mahabharata* are used to prove that ancient aircraft were in use more than four thousand years ago. Included in this book is the entire Fourth Century BC manuscript *Vimaanika Shastra* by the ancient author Maharishi Bharadwaaja. Also included are chapters on Atlantean technology, the incredible Rama Empire of India and the devastating wars that destroyed it.
334 PAGES. 6x9 PAPERBACK. ILLUSTRATED. $15.95. CODE: VAA

LOST CONTINENTS & THE HOLLOW EARTH
I Remember Lemuria and the Shaver Mystery
by David Hatcher Childress & Richard Shaver
Shaver's rare 1948 book *I Remember Lemuria* is reprinted in its entirety, and the book is packed with illustrations from Ray Palmer's *Amazing Stories* magazine of the 1940s. Palmer and Shaver told of tunnels running through the earth—tunnels inhabited by the Deros and Teros, humanoids from an ancient spacefaring race that had inhabited the earth, eventually going underground, hundreds of thousands of years ago. Childress discusses the famous hollow earth books and delves deep into whatever reality may be behind the stories of tunnels in the earth. Operation High Jump to Antarctica in 1947 and Admiral Byrd's bizarre statements, tunnel systems in South America and Tibet, the underground world of Agartha, the belief of UFOs coming from the South Pole, more.
344 PAGES. 6x9 PAPERBACK. ILLUSTRATED. $16.95. CODE: LCHE

ATLANTIS & THE POWER SYSTEM OF THE GODS
by David Hatcher Childress and Bill Clendenon
Childress' fascinating analysis of Nikola Tesla's broadcast system in light of Edgar Cayce's "Terrible Crystal" and the obelisks of ancient Egypt and Ethiopia. Includes: Atlantis and its crystal power towers that broadcast energy; how these incredible power stations may still exist today; inventor Nikola Tesla's nearly identical system of power transmission; Mercury Proton Gyros and mercury vortex propulsion; more. Richly illustrated, and packed with evidence that Atlantis not only existed—it had a world-wide energy system more sophisticated than ours today.
246 PAGES. 6x9 PAPERBACK. ILLUSTRATED. $15.95. CODE: APSG

THE ANTI-GRAVITY HANDBOOK
edited by David Hatcher Childress
The new expanded compilation of material on Anti-Gravity, Free Energy, Flying Saucer Propulsion, UFOs, Suppressed Technology, NASA Cover-ups and more. Highly illustrated with patents, technical illustrations and photos. This revised and expanded edition has more material, including photos of Area 51, Nevada, the government's secret testing facility. This classic on weird science is back in a new format!
230 PAGES. 7x10 PAPERBACK. ILLUSTRATED. $16.95. CODE: AGH

ANTI–GRAVITY & THE WORLD GRID
Is the earth surrounded by an intricate electromagnetic grid network offering free energy? This compilation of material on ley lines and world power points contains chapters on the geography, mathematics, and light harmonics of the earth grid. Learn the purpose of ley lines and ancient megalithic structures located on the grid. Discover how the grid made the Philadelphia Experiment possible. Explore the Coral Castle and many other mysteries, including acoustic levitation, Tesla Shields and scalar wave weaponry. Browse through the section on anti-gravity patents, and research resources.
274 PAGES. 7x10 PAPERBACK. ILLUSTRATED. $14.95. CODE: AGW

ANTI–GRAVITY & THE UNIFIED FIELD
edited by David Hatcher Childress
Is Einstein's Unified Field Theory the answer to all of our energy problems? Explored in this compilation of material is how gravity, electricity and magnetism manifest from a unified field around us. Why artificial gravity is possible; secrets of UFO propulsion; free energy; Nikola Tesla and anti-gravity airships of the 20s and 30s; flying saucers as superconducting whirls of plasma; anti-mass generators; vortex propulsion; suppressed technology; government cover-ups; gravitational pulse drive; spacecraft & more.
240 PAGES. 7x10 PAPERBACK. ILLUSTRATED. $14.95. CODE: AGU

THE TIME TRAVEL HANDBOOK
A Manual of Practical Teleportation & Time Travel
edited by David Hatcher Childress
The Time Travel Handbook takes the reader beyond the government experiments and deep into the uncharted territory of early time travellers such as Nikola Tesla and Guglielmo Marconi and their alleged time travel experiments, as well as the Wilson Brothers of EMI and their connection to the Philadelphia Experiment—the U.S. Navy's forays into invisibility, time travel, and teleportation. Childress looks into the claims of time travelling individuals, and investigates the unusual claim that the pyramids on Mars were built in the future and sent back in time. A highly visual, large format book, with patents, photos and schematics. Be the first on your block to build your own time travel device!
316 PAGES. 7x10 PAPERBACK. ILLUSTRATED. $16.95. CODE: TTH

MAPS OF THE ANCIENT SEA KINGS
Evidence of Advanced Civilization in the Ice Age
by Charles H. Hapgood
Charles Hapgood has found the evidence in the Piri Reis Map that shows Antarctica, the Hadji Ahmed map, the Oronteus Finaeus and other amazing maps. Hapgood concluded that these maps were made from more ancient maps from the various ancient archives around the world, now lost. Not only were these unknown people more advanced in mapmaking than any people prior to the 18th century, it appears they mapped all the continents. The Americas were mapped thousands of years before Columbus. Antarctica was mapped when its coasts were free of ice!
316 PAGES. 7X10 PAPERBACK. ILLUSTRATED. BIBLIOGRAPHY & INDEX. $19.95. CODE: MASK

PATH OF THE POLE
Cataclysmic Pole Shift Geology
by Charles H. Hapgood
Maps of the Ancient Sea Kings author Hapgood's classic book *Path of the Pole* is back in print! Hapgood researched Antarctica, ancient maps and the geological record to conclude that the Earth's crust has slipped on the inner core many times in the past, changing the position of the pole. *Path of the Pole* discusses the various "pole shifts" in Earth's past, giving evidence for each one, and moves on to possible future pole shifts.
356 PAGES. 6x9 PAPERBACK. ILLUSTRATED. $16.95. CODE: POP

SECRETS OF THE HOLY LANCE
The Spear of Destiny in History & Legend
by Jerry E. Smith
Secrets of the Holy Lance traces the Spear from its possession by Constantine, Rome's first Christian Caesar, to Charlemagne's claim that with it he ruled the Holy Roman Empire by Divine Right, and on through two thousand years of kings and emperors, until it came within Hitler's grasp—and beyond! Did it rest for a while in Antarctic ice? Is it now hidden in Europe, awaiting the next person to claim its awesome power? Neither debunking nor worshiping, *Secrets of the Holy Lance* seeks to pierce the veil of myth and mystery around the Spear. Mere belief that it was infused with magic by virtue of its shedding the Savior's blood has made men kings. But what if it's more? What are "the powers it serves"?
312 PAGES. 6x9 PAPERBACK. ILLUSTRATED. BIBLIOGRAPHY. $16.95. CODE: SOHL

THE FANTASTIC INVENTIONS OF NIKOLA TESLA
by Nikola Tesla with additional material by David Hatcher Childress
This book is a readable compendium of patents, diagrams, photos and explanations of the many incredible inventions of the originator of the modern era of electrification. In Tesla's own words are such topics as wireless transmission of power, death rays, and radio-controlled airships. In addition, rare material on a secret city built at a remote jungle site in South America by one of Tesla's students, Guglielmo Marconi. Marconi's secret group claims to have built flying saucers in the 1940s and to have gone to Mars in the early 1950s! Incredible photos of these Tesla craft are included. •His plan to transmit free electricity into the atmosphere. •How electrical devices would work using only small antennas. •Why unlimited power could be utilized anywhere on earth. •How radio and radar technology can be used as death-ray weapons in Star Wars.
342 PAGES. 6x9 PAPERBACK. ILLUSTRATED. $16.95. CODE: FINT

REICH OF THE BLACK SUN
Nazi Secret Weapons & the Cold War Allied Legend
by Joseph P. Farrell

Why were the Allies worried about an atom bomb attack by the Germans in 1944? Why did the Soviets threaten to use poison gas against the Germans? Why did Hitler in 1945 insist that holding Prague could win the war for the Third Reich? Why did US General George Patton's Third Army race for the Skoda works at Pilsen in Czechoslovakia instead of Berlin? Why did the US Army not test the uranium atom bomb it dropped on Hiroshima? Why did the Luftwaffe fly a non-stop round trip mission to within twenty miles of New York City in 1944? *Reich of the Black Sun* takes the reader on a scientific-historical journey in order to answer these questions. Arguing that Nazi Germany actually won the race for the atom bomb in late 1944,

352 PAGES. 6x9 PAPERBACK. ILLUSTRATED. BIBLIOGRAPHY. $16.95.
CODE: ROBS

THE GIZA DEATH STAR
The Paleophysics of the Great Pyramid & the Military Complex at Giza
by Joseph P. Farrell

Was the Giza complex part of a military installation over 10,000 years ago? Chapters include: An Archaeology of Mass Destruction, Thoth and Theories; The Machine Hypothesis; Pythagoras, Plato, Planck, and the Pyramid; The Weapon Hypothesis; Encoded Harmonics of the Planck Units in the Great Pyramid; High Freqquency Direct Current "Impulse" Technology; The Grand Gallery and its Crystals: Gravito-acoustic Resonators; The Other Two Large Pyramids; the "Causeways," and the "Temples"; A Phase Conjugate Howitzer; Evidence of the Use of Weapons of Mass Destruction in Ancient Times; more.

290 PAGES. 6x9 PAPERBACK. ILLUSTRATED. $16.95. CODE: GDS

THE GIZA DEATH STAR DEPLOYED
The Physics & Engineering of the Great Pyramid
by Joseph P. Farrell

Farrell expands on his thesis that the Great Pyramid was a maser, designed as a weapon and eventually deployed—with disastrous results to the solar system. Includes: Exploding Planets: A Brief History of the Exoteric and Esoteric Investigations of the Great Pyramid; No Machines, Please!; The Stargate Conspiracy; The Scalar Weapons; Message or Machine?; A Tesla Analysis of the Putative Physics and Engineering of the Giza Death Star; Cohering the Zero Point, Vacuum Energy, Flux: Feedback Loops and Tetrahedral Physics; and more.

290 PAGES. 6x9 PAPERBACK. ILLUSTRATED. $16.95. CODE: GDSD

THE GIZA DEATH STAR DESTROYED
The Ancient War For Future Science
by Joseph P. Farrell

Farrell moves on to events of the final days of the Giza Death Star and its awesome power. These final events, eventually leading up to the destruction of this giant machine, are dissected one by one, leading us to the eventual abandonment of the Giza Military Complex—an event that hurled civilization back into the Stone Age. Chapters include: The Mars-Earth Connection; The Lost "Root Races" and the Moral Reasons for the Flood; The Destruction of Krypton: The Electrodynamic Solar System, Exploding Planets and Ancient Wars; Turning the Stream of the Flood: the Origin of Secret Societies and Esoteric Traditions; The Quest to Recover Ancient Mega-Technology; Non-Equilibrium Paleophysics; Monatomic Paleophysics; Frequencies, Vortices and Mass Particles; "Acoustic" Intensity of Fields; The Pyramid of Crystals; tons more.

292 pages. 6x9 paperback. Illustrated. $16.95. Code: GDES

THE TESLA PAPERS
Nikola Tesla on Free Energy &
Wireless Transmission of Power
by Nikola Tesla, edited by David Hatcher Childress

David Hatcher Childress takes us into the incredible world of Nikola Tesla and his amazing inventions. Tesla's fantastic vision of the future, including wireless power, anti-gravity, free energy and highly advanced solar power. Also included are some of the papers, patents and material collected on Tesla at the Colorado Springs Tesla Symposiums, including papers on: •The Secret History of Wireless Transmission •Tesla and the Magnifying Transmitter •Design and Construction of a Half-Wave Tesla Coil •Electrostatics: A Key to Free Energy •Progress in Zero-Point Energy Research •Electromagnetic Energy from Antennas to Atoms •Tesla's Particle Beam Technology •Fundamental Excitatory Modes of the Earth-Ionosphere Cavity

325 PAGES. 8x10 PAPERBACK. ILLUSTRATED. $16.95. CODE: TTP

UFOS AND ANTI-GRAVITY
Piece For A Jig-Saw
by Leonard G. Cramp

Leonard G. Cramp's 1966 classic book on flying saucer propulsion and suppressed technology is a highly technical look at the UFO phenomena by a trained scientist. Cramp first introduces the idea of 'anti-gravity' and introduces us to the various theories of gravitation. He then examines the technology necessary to build a flying saucer and examines in great detail the technical aspects of such a craft. Cramp's book is a wealth of material and diagrams on flying saucers, anti-gravity, suppressed technology, G-fields and UFOs. Chapters include Crossroads of Aerodynamics, Aerodynamic Saucers, Limitations of Rocketry, Gravitation and the Ether, Gravitational Spaceships, G-Field Lift Effects, The Bi-Field Theory, VTOL and Hovercraft, Analysis of UFO photos, more.

388 PAGES. 6x9 PAPERBACK. ILLUSTRATED. $16.95. CODE: UAG

THE COSMIC MATRIX
Piece for a Jig-Saw, Part Two
by Leonard G. Cramp

Cramp examines anti-gravity effects and theorizes that this super-science used by the craft—described in detail in the book—can lift mankind into a new level of technology, transportation and understanding of the universe. The book takes a close look at gravity control, time travel, and the interlocking web of energy between all planets in our solar system with Leonard's unique technical diagrams. A fantastic voyage into the present and future!

364 PAGES. 6x9 PAPERBACK. ILLUSTRATED. BIBLIOGRAPHY. $16.00. CODE: CMX

THE A.T. FACTOR
A Scientists Encounter with UFOs
by Leonard Cramp

British aerospace engineer Cramp began much of the scientific anti-gravity and UFO propulsion analysis back in 1955 with his landmark book *Space, Gravity & the Flying Saucer* (out-of-print and rare). In this final book, Cramp brings to a close his detailed and controversial study of UFOs and Anti-Gravity.

324 PAGES. 6x9 PAPERBACK. ILLUSTRATED. BIBLIOGRAPHY. INDEX. $16.95. CODE: ATF

THE FREE-ENERGY DEVICE HANDBOOK
A Compilation of Patents and Reports
by David Hatcher Childress

A large-format compilation of various patents, papers, descriptions and diagrams concerning free-energy devices and systems. *The Free-Energy Device Handbook* is a visual tool for experimenters and researchers into magnetic motors and other "over-unity" devices. With chapters on the Adams Motor, the Hans Coler Generator, cold fusion, superconductors, "N" machines, space-energy generators, Nikola Tesla, T. Townsend Brown, and the latest in free-energy devices. Packed with photos, technical diagrams, patents and fascinating information, this book belongs on every science shelf.
292 PAGES. 8x10 PAPERBACK. ILLUSTRATED. $16.95. CODE: FEH

THE ENERGY GRID
Harmonic 695, The Pulse of the Universe
by Captain Bruce Cathie

This is the breakthrough book that explores the incredible potential of the Energy Grid and the Earth's Unified Field all around us. Cathie's first book, *Harmonic 33*, was published in 1968 when he was a commercial pilot in New Zealand. Since then, Captain Bruce Cathie has been the premier investigator into the amazing potential of the infinite energy that surrounds our planet every microsecond. Cathie investigates the Harmonics of Light and how the Energy Grid is created. In this amazing book are chapters on UFO Propulsion, Nikola Tesla, Unified Equations, the Mysterious Aerials, Pythagoras & the Grid, Nuclear Detonation and the Grid, Maps of the Ancients, an Australian Stonehenge examined, more.
255 PAGES. 6x9 TRADEPAPER. ILLUSTRATED. $15.95. CODE: TEG

THE BRIDGE TO INFINITY
Harmonic 371244
by Captain Bruce Cathie

Cathie has popularized the concept that the earth is crisscrossed by an electromagnetic grid system that can be used for anti-gravity, free energy, levitation and more. The book includes a new analysis of the harmonic nature of reality, acoustic levitation, pyramid power, harmonic receiver towers and UFO propulsion. It concludes that today's scientists have at their command a fantastic store of knowledge with which to advance the welfare of the human race.
204 PAGES. 6x9 TRADEPAPER. ILLUSTRATED. $14.95. CODE: BTF

THE HARMONIC CONQUEST OF SPACE
by Captain Bruce Cathie

Chapters include: Mathematics of the World Grid; the Harmonics of Hiroshima and Nagasaki; Harmonic Transmission and Receiving; the Link Between Human Brain Waves; the Cavity Resonance between the Earth; the Ionosphere and Gravity; Edgar Cayce—the Harmonics of the Subconscious; Stonehenge; the Harmonics of the Moon; the Pyramids of Mars; Nikola Tesla's Electric Car; the Robert Adams Pulsed Electric Motor Generator; Harmonic Clues to the Unified Field; and more. Also included are tables showing the harmonic relations between the earth's magnetic field, the speed of light, and anti-gravity/gravity acceleration at different points on the earth's surface. New chapters in this edition on the giant stone spheres of Costa Rica, Atomic Tests and Volcanic Activity, and a chapter on Ayers Rock analysed with Stone Mountain, Georgia.
248 PAGES. 6x9. PAPERBACK. ILLUSTRATED. BIBLIOGRAPHY. $16.95. CODE: HCS

GRAVITATIONAL MANIPULATION OF DOMED CRAFT
UFO Propulsion Dynamics
by Paul E. Potter

Potter's precise and lavish illustrations allow the reader to enter directly into the realm of the advanced technological engineer and to understand, quite straightforwardly, the aliens' methods of energy manipulation: their methods of electrical power generation; how they purposely designed their craft to employ the kinds of energy dynamics that are exclusive to space (discoverable in our astrophysics) in order that their craft may generate both attractive and repulsive gravitational forces; their control over the mass-density matrix surrounding their craft enabling them to alter their physical dimensions and even manufacture their own frame of reference in respect to time. Includes a 16-page color insert.

624 pages. 7x10 Paperback. Illustrated. References. $24.00. Code: GMDC

TAPPING THE ZERO POINT ENERGY
Free Energy & Anti-Gravity in Today's Physics
by Moray B. King

King explains how free energy and anti-gravity are possible. The theories of the zero point energy maintain there are tremendous fluctuations of electrical field energy imbedded within the fabric of space. This book tells how, in the 1930s, inventor T. Henry Moray could produce a fifty kilowatt "free energy" machine; how an electrified plasma vortex creates anti-gravity; how the Pons/Fleischmann "cold fusion" experiment could produce tremendous heat without fusion; and how certain experiments might produce a gravitational anomaly.

180 PAGES. 5x8 PAPERBACK. ILLUSTRATED. $12.95. CODE: TAP

QUEST FOR ZERO-POINT ENERGY
Engineering Principles for "Free Energy"
by Moray B. King

King expands, with diagrams, on how free energy and anti-gravity are possible. The theories of zero point energy maintain there are tremendous fluctuations of electrical field energy embedded within the fabric of space. King explains the following topics: TFundamentals of a Zero-Point Energy Technology; Vacuum Energy Vortices; The Super Tube; Charge Clusters: The Basis of Zero-Point Energy Inventions; Vortex Filaments, Torsion Fields and the Zero-Point Energy; Transforming the Planet with a Zero-Point Energy Experiment; Dual Vortex Forms: The Key to a Large Zero-Point Energy Coherence. Packed with diagrams, patents and photos.

224 PAGES. 6x9 PAPERBACK. ILLUSTRATED. $14.95. CODE: QZPE

DARK MOON
Apollo and the Whistleblowers
by Mary Bennett and David Percy

Did you know a second craft was going to the Moon at the same time as Apollo 11? Do you know that potentially lethal radiation is prevalent throughout deep space? Do you know there are serious discrepancies in the account of the Apollo 13 'accident'? Did you know that 'live' color TV from the Moon was not actually live at all? Did you know that the Lunar Surface Camera had no viewfinder? Do you know that lighting was used in the Apollo photographs—yet no lighting equipment was taken to the Moon? All these questions, and more, are discussed in great detail by British researchers Bennett and Percy in *Dark Moon*, the definitive book (nearly 600 pages) on the possible faking of the Apollo Moon missions. Tons of NASA photos analyzed for possible deceptions.

568 PAGES. 6x9 PAPERBACK. ILLUSTRATED. BIBLIOGRAPHY. INDEX. **$32.00. CODE: DMO**

THE MYSTERY OF THE OLMECS
by David Hatcher Childress

The Olmecs were not acknowledged to have existed as a civilization until an international archeological meeting in Mexico City in 1942. Now, the Olmecs are slowly being recognized as the Mother Culture of Mesoamerica, having invented writing, the ball game and the "Mayan" Calendar. But who were the Olmecs? Where did they come from? What happened to them? How sophisticated was their culture? Why are many Olmec statues and figurines seemingly of foreign peoples such as Africans, Europeans and Chinese? Is there a link with Atlantis? In this heavily illustrated book, join Childress in search of the lost cities of the Olmecs! Chapters include: The Mystery of Quizuo; The Mystery of Transoceanic Trade; The Mystery of Cranial Deformation; more.

296 PAGES. 6x9 PAPERBACK. ILLUSTRATED. BIBLIOGRAPHY. COLOR SECTION. $20.00. CODE: MOLM

THE LAND OF OSIRIS
An Introduction to Khemitology
by Stephen S. Mehler

Was there an advanced prehistoric civilization in ancient Egypt who built the great pyramids and carved the Great Sphinx? Did the pyramids serve as energy devices and not as tombs for kings? Mehler has uncovered an indigenous oral tradition that still exists in Egypt, and has been fortunate to have studied with a living master of this tradition, Abd'El Hakim Awyan. Mehler has also been given permission to present these teachings to the Western world, teachings that unfold a whole new understanding of ancient Egypt . Chapters include: Egyptology and Its Paradigms; Asgat Nefer—The Harmony of Water; Khemit and the Myth of Atlantis; The Extraterrestrial Question; more.

272 PAGES. 6x9 PAPERBACK. ILLUSTRATED. COLOR SECTION. BIBLIOGRAPHY. $18.00 CODE: LOOS

ABOMINABLE SNOWMEN:
LEGEND COME TO LIFE
The Story of Sub-Humans on Six Continents from the Early Ice Age Until Today
by Ivan T. Sanderson

Do "Abominable Snowmen" exist? Prepare yourself for a shock. In the opinion of one of the world's leading naturalists, not one, but possibly four kinds, still walk the earth! Do they really live on the fringes of the towering Himalayas and the edge of myth-haunted Tibet? From how many areas in the world have factual reports of wild, strange, hairy men emanated? Reports of strange apemen have come in from every continent, except Antarctica.

525 PAGES. 6x9 PAPERBACK. ILLUSTRATED. BIBLIOGRAPHY. INDEX. $16.95. CODE: ABML

INVISIBLE RESIDENTS
The Reality of Underwater UFOS
by Ivan T. Sanderson

In this book, Sanderson, a renowned zoologist with a keen interest in the paranormal, puts forward the curious theory that "OINTS"—Other Intelligences—live under the Earth's oceans. This underwater, parallel, civilization may be twice as old as Homo sapiens, he proposes, and may have "developed what we call space flight." Sanderson postulates that the OINTS are behind many UFO sightings as well as the mysterious disappearances of aircraft and ships in the Bermuda Triangle. What better place to have an impenetrable base than deep within the oceans of the planet? Sanderson offers here an exhaustive study of USOs (Unidentified Submarine Objects) observed in nearly every part of the world.

298 PAGES. 6x9 PAPERBACK. ILLUSTRATED. BIBLIOGRAPHY. INDEX. $16.95. CODE: INVS

PIRATES & THE LOST TEMPLAR FLEET
The Secret Naval War Between the Templars & the Vatican
by David Hatcher Childress

Childress takes us into the fascinating world of maverick sea captains who were Knights Templar (and later Scottish Rite Free Masons) who battled the ships that sailed for the Pope. The lost Templar fleet was originally based at La Rochelle in southern France, but fled to the deep fiords of Scotland upon the dissolution of the Order by King Phillip. This banned fleet of ships was later commanded by the St. Clair family of Rosslyn Chapel (birthplace of Free Masonry). St. Clair and his Templars made a voyage to Canada in the year 1298 AD, nearly 100 years before Columbus! Later, this fleet of ships and new ones to come, flew the Skull and Crossbones, the symbol of the Knights Templar.

320 PAGES. 6x9 PAPERBACK. ILLUSTRATED. BIBLIOGRAPHY. $16.95.
CODE: PLTF

TEMPLARS' LEGACY IN MONTREAL
The New Jerusalem
by Francine Bernier

The book reveals the links between Montreal and: John the Baptist as patron saint; Melchizedek, the first king-priest and a father figure to the Templars and the Essenes; Stella Maris, the Star of the Sea from Mount Carmel; the Phrygian goddess Cybele as the androgynous Mother of the Church; St. Blaise, the Armenian healer or "Therapeut"- the patron saint of the stonemasons and a major figure to the Benedictine Order and the Templars; the presence of two Black Virgins; an intriguing family coat of arms with twelve blue apples; and more.

352 PAGES. 6x9 PAPERBACK. ILLUSTRATED. BIBLIOGRAPHY. $21.95.
CODE: TLIM

THE HISTORY OF THE KNIGHTS TEMPLARS
by Charles G. Addison, introduction by David Hatcher Childress

Chapters on the origin of the Templars, their popularity in Europe and their rivalry with the Knights of St. John, later to be known as the Knights of Malta. Detailed information on the activities of the Templars in the Holy Land, and the 1312 AD suppression of the Templars in France and other countries, which culminated in the execution of Jacques de Molay and the continuation of the Knights Templars in England and Scotland; the formation of the society of Knights Templars in London; and the rebuilding of the Temple in 1816. Plus a lengthy intro about the lost Templar fleet and its North American sea routes.

395 PAGES. 6x9 PAPERBACK. ILLUSTRATED. $16.95. CODE: HKT

OTTO RAHN AND THE QUEST FOR THE HOLY GRAIL
The Amazing Life of the Real "Indiana Jones"
by Nigel Graddon

Otto Rahn led a life of incredible adventure in southern France in the early 1930s. The Hessian language scholar is said to have found runic Grail tablets in the Pyrenean grottoes, and decoded hidden messages within the medieval Grail masterwork *Parsifal*. The fabulous artifacts identified by Rahn were believed by Himmler to include the Grail Cup, the Spear of Destiny, the Tablets of Moses, the Ark of the Covenant, the Sword and Harp of David, the Sacred Candelabra and the Golden Urn of Manna. Some believe that Rahn was a Nazi guru who wielded immense influence on his elders and "betters" within the Hitler regime, persuading them that the Grail was the Sacred Book of the Aryans, which, once obtained, would justify their extreme political theories and revivify the ancient Germanic myths. But things are never as they seem, and as new facts emerge about Otto Rahn a far more extraordinary story unfolds.

450 pages. 6x9 Paperback. Illustrated. Appendix. Index. $18.95.
Code: ORQG

EYE OF THE PHOENIX
Mysterious Visions and
Secrets of the American Southwest
by Gary David

GaryDavid explores enigmas and anomalies in the vast American Southwest. Contents includes: The Great Pyramids of Arizona; Meteor Crater—Arizona's First Bonanza?; Chaco Canyon—Ancient City of the Dog Star; Phoenix—Masonic Metropolis in the Valley of the Sun; Along the 33rd Parallel—A Global Mystery Circle; The Flying Shields of the Hopi Katsinam; Is the Starchild a Hopi God?; The Ant People of Orion—Ancient Star Beings of the Hopi; Serpent Knights of the Round Temple; The Nagas—Origin of the Hopi Snake Clan?; The Tau (or T-shaped) Cross—Hopi/Maya/Egyptian Connections; The Hopi Stone Tablets of Techqua Ikachi; The Four Arms of Destiny—Swastikas in the Hopi World of the End Times; and more.

348 pages. 6x9 Paperback. Illustrated. Bibliography. $16.95. Code: EOPX

THE ORION PROPHECY
Egyptian and Mayan Prophecies
on the Cataclysm of 2012
by Patrick Geryl and Gino Ratinckx

In the year 2012 the Earth awaits a super catastrophe: its magnetic field will reverse in one go. Phenomenal earthquakes and tidal waves will completely destroy our civilization. These dire predictions stem from the Mayans and Egyptians—descendants of the legendary Atlantis. The Atlanteans were able to exactly predict the previous world-wide flood in 9792 BC. They built tens of thousands of boats and escaped to South America and Egypt. In the year 2012 Venus, Orion and several others stars will take the same 'code-positions' as in 9792 BC!

324 PAGES. 6x9 PAPERBACK. ILLUSTRATED. $16.95. CODE: ORP

PRODIGAL GENIUS
The Life of Nikola Tesla
by John J. O'Neill

This special edition of O'Neill's book has many rare photographs of Tesla and his most advanced inventions. Tesla's eccentric personality gives his life story a strange romantic quality. He made his first million before he was forty, yet gave up his royalties in a gesture of friendship, and died almost in poverty. Tesla could see an invention in 3-D, from every angle, within his mind, before it was built; how he refused to accept the Nobel Prize; his friendships with Mark Twain, George Westinghouse and competition with Thomas Edison. Deluxe, illustrated edition.

408 pages. 6x9 Paperback. Illustrated. Bibliography. $18.95. Code: PRG

STALKING THE TRICKSTERS:
Shapeshifters, Skinwalkers, Dark Adepts and 2012
By Christopher O'Brien
Foreword by David Perkins

Manifestations of the Trickster persona such as cryptids, elementals, werewolves, demons, vampires and dancing devils have permeated human experience since before the dawn of civilization. But today, very little is publicly known about The Tricksters. Who are they? What is their agenda? Known by many names including fools, sages, Loki, men-in-black, skinwalkers, shapeshifters, jokers, *jinn,* sorcerers, and witches, Tricksters provide us with a direct conduit to the unknown in the 21st century. Can these denizens of phenomenal events be attempting to communicate a warning to humanity in this uncertain age of prophesied change? Take a journey around the world stalking the tricksters!

354 Pages. 6x9 Paperback. Illustrated. Bibliography. $18.95. Code: STT

THE CRYSTAL SKULLS
Astonishing Portals to Man's Past
by David Hatcher Childress and Stephen S. Mehler

Childress introduces the technology and lore of crystals, and then plunges into the turbulent times of the Mexican Revolution form the backdrop for the rollicking adventures of Ambrose Bierce, the renowned journalist who went missing in the jungles in 1913, and F.A. Mitchell-Hedges, the notorious adventurer who emerged from the jungles with the most famous of the crystal skulls. Mehler shares his extensive knowledge of and experience with crystal skulls. Having been involved in the field since the 1980s, he has personally examined many of the most influential skulls, and has worked with the leaders in crystal skull research, including the inimitable Nick Nocerino, who developed a meticulous methodology for the purpose of examining the skulls.
294 pages. 6x9 Paperback. Illustrated. Bibliography. $18.95. Code: CRSK

THE INCREDIBLE LIGHT BEINGS OF THE COSMOS
Are Orbs Intelligent Light Beings from the Cosmos?
by Antonia Scott-Clark

Scott-Clark has experienced orbs for many years, but started photographing them in earnest in the year 2000 when the "Light Beings" entered her life. She took these very seriously and set about privately researching orb occurrences. The incredible results of her findings are presented here, along with many of her spectacular photographs. With her friend, GoGos lead singer Belinda Carlisle, Antonia tells of her many adventures with orbs. Find the answers to questions such as: Can you see orbs with the naked eye?; Are orbs intelligent?; What are the Black Villages?; What is the connection between orbs and crop circles? Antonia gives detailed instruction on how to photograph orbs, and how to communicate with these Light Beings of the Cosmos.
334 pages. 6x9 Paperback. Illustrated. References. $19.95. Code: ILBC

AXIS OF THE WORLD
The Search for the Oldest American Civilization
by Igor Witkowski

Polish author Witkowski's research reveals remnants of a high civilization that was able to exert its influence on almost the entire planet, and did so with full consciousness. Sites around South America show that this was not just one of the places influenced by this culture, but a place where they built their crowning achievements. Easter Island, in the southeastern Pacific, constitutes one of them. The Rongo-Rongo language that developed there points westward to the Indus Valley. Taken together, the facts presented by Witkowski provide a fresh, new proof that an antediluvian, great civilization flourished several millennia ago.
220 pages. 6x9 Paperback. Illustrated. References. $18.95. Code: AXOW

LEY LINE & EARTH ENERGIES
An Extraordinary Journey into the Earth's Natural Energy System
by David Cowan & Chris Arnold

The mysterious standing stones, burial grounds and stone circles that lace Europe, the British Isles and other areas have intrigued scientists, writers, artists and travellers through the centuries. How do ley lines work? How did our ancestors use Earth energy to map their sacred sites and burial grounds? How do ghosts and poltergeists interact with Earth energy? How can Earth spirals and black spots affect our health? This exploration shows how natural forces affect our behavior, how they can be used to enhance our health and well being.
368 PAGES. 6x9 PAPERBACK. ILLUSTRATED. $18.95. CODE: LLEE

SECRETS OF THE UNIFIED FIELD
The Philadelphia Experiment, the Nazi Bell, and the Discarded Theory
by Joseph P. Farrell

Farrell examines the now discarded Unified Field Theory. American and German wartime scientists and engineers determined that, while the theory was incomplete, it could nevertheless be engineered. Chapters include: The Meanings of "Torsion"; Wringing an Aluminum Can; The Mistake in Unified Field Theories and Their Discarding by Contemporary Physics; Three Routes to the Doomsday Weapon: Quantum Potential, Torsion, and Vortices; Tesla's Meeting with FDR; Arnold Sommerfeld and Electromagnetic Radar Stealth; Electromagnetic Phase Conjugations, Phase Conjugate Mirrors, and Templates; The Unified Field Theory, the Torsion Tensor, and Igor Witkowski's Idea of the Plasma Focus; tons more.
340 pages. 6x9 Paperback. Illustrated. Bibliography. Index. $18.95. Code: SOUF

NAZI INTERNATIONAL
The Nazi's Postwar Plan to Control Finance, Conflict, Physics and Space
by Joseph P. Farrell

Beginning with prewar corporate partnerships in the USA he moves on to the surrender of Nazi Germany, and evacuation plans of the Germans. He then covers the vast, and still-little-known recreation of Nazi Germany in South America with help of Juan Peron, I.G. Farben and Martin Bormann. Farrell then covers Nazi Germany's penetration of the Muslim world before moving on to the development and control of new energy technologies including the Bariloche Fusion Project, Dr. Philo Farnsworth's Plasmator, and the work of Dr. Nikolai Kozyrev. Finally, Farrell discusses the Nazi desire to control space, and examines their connection with NASA, the esoteric meaning of NASA Mission Patches.
412 pages. 6x9 Paperback. Illustrated. References. $19.95. Code: NZIN

ARKTOS
The Myth of the Pole in Science, Symbolism, and Nazi Survival
by Joscelyn Godwin

A scholarly treatment of catastrophes, ancient myths and the Nazi Occult beliefs. Explored are the many tales of an ancient race said to have lived in the Arctic regions, such as Thule and Hyperborea. Progressing onward, the book looks at modern polar legends including the survival of Hitler, German bases in Antarctica, UFOs, the hollow earth, Agartha and Shambala, more.
220 PAGES. 6x9 PAPERBACK. ILLUSTRATED. $16.95. CODE: ARK

GUARDIANS OF THE HOLY GRAIL
by Mark Amaru Pinkham

This book presents this extremely ancient Holy Grail lineage from Asia and how the Knights Templar were initiated into it. It also reveals how the ancient Asian wisdom regarding the Holy Grail became the foundation for the Holy Grail legends of the west while also serving as the bedrock of the European Secret Societies, which included the Freemasons, Rosicrucians, and the Illuminati. Also: The Fisher Kings; The Middle Eastern mystery schools, such as the Assassins and Yezidhi; The ancient Holy Grail lineage from Sri Lanka and the Templar Knights' initiation into it; The head of John the Baptist and its importance to the Templars; The secret Templar initiation with grotesque Baphomet, the infamous Head of Wisdom; more.
248 PAGES. 6x9 PAPERBACK. ILLUSTRATED. $16.95. CODE: GOHG

THE BOOK OF ENOCH
translated by Richard Laurence
This is a reprint of the Apocryphal *Book of Enoch the Prophet* which was first discovered in Abyssinia in the year 1773 by a Scottish explorer named James Bruce. One of the main influences from the book is its explanation of evil coming into the world with the arrival of the "fallen angels." Enoch acts as a scribe, writing up a petition on behalf of these fallen angels, or fallen ones, to be given to a higher power for ultimate judgment. Christianity adopted some ideas from Enoch, including the Final Judgment, the concept of demons, the origins of evil and the fallen angels, and the coming of a Messiah and ultimately, a Messianic kingdom.
224 PAGES. 6x9 PAPERBACK. ILLUSTRATED. INDEX. $16.95. CODE: BOE

SUNS OF GOD
Krishna, Buddha and Christ Unveiled
by Acharya S
Over the past several centuries, the Big Three spiritual leaders have been the Lords Christ, Krishna and Buddha, whose stories and teachings are so remarkably similar as to confound and amaze those who encounter them. As classically educated archaeologist, historian, mythologist and linguist Acharya S thoroughly reveals, these striking parallels exist not because these godmen were "historical" personages who "walked the earth" but because they are personifications of the central focus of the famous and scandalous "mysteries." These mysteries date back thousands of years and are found globally, reflecting an ancient tradition steeped in awe and intrigue.
428 PAGES. 6x9 PAPERBACK. ILLUSTRATED. BIBLIOGRAPHY. INDEX. $18.95. CODE: SUNG

THE CHRIST CONSPIRACY
The Greatest Story Ever Sold
by Acharya S.
In this highly controversial and explosive book, archaeologist, historian, mythologist and linguist Acharya S. marshals an enormous amount of startling evidence to demonstrate that Christianity and the story of Jesus Christ were created by members of various secret societies, mystery schools and religions in order to unify the Roman Empire under one state religion. In developing such a fabrication, this multinational cabal drew upon a multitude of myths and rituals that existed long before the Christian era, and reworked them for centuries into the religion passed down to us today. Contrary to popular belief, Jesus was many characters rolled into one. These characters personified the ubiquitous solar myth, and their exploits were well known, as reflected by such popular deities as Mithras, Heracles/Hercules, Dionysos and many others throughout the Roman Empire and beyond.
436 PAGES. 6x9 PAPERBACK. ILLUSTRATED. $16.95. CODE: CHRC

EDEN IN EGYPT
by Ralph Ellis
The story of Adam and Eve from the Book of Genesis is perhaps one of the best-known stories in circulation, even today, and yet nobody really knows where this tale came from or what it means. But even a cursory glance at the text will demonstrate the origins of this tale, for the river of Eden is described as having four branches. There is only one river in this part of the world that fits this description, and that is the Nile, with the four branches forming the Nile Delta. According to Ellis, Judaism was based upon the reign of the pharaoh Akhenaton, because the solitary Judaic god was known as Adhon while this pharaoh's solitary god was called Aton or Adjon. But what of the identities of Adam and Eve? Includes 16 page color section.
320 PAGES. 6x9 PAPERBACK. ILLUSTRATED. BIBLIOGRAPHY. INDEX. $20.00. CODE: EIE

ORDER FORM

10% Discount When You Order 3 or More Items!

One Adventure Place
P.O. Box 74
Kempton, Illinois 60946
United States of America
Tel.: 815-253-6390 • Fax: 815-253-6300
Email: auphq@frontiernet.net
http://www.adventuresunlimitedpress.com

ORDERING INSTRUCTIONS

✓ Remit by USD$ Check, Money Order or Credit Card

✓ Visa, Master Card, Discover & AmEx Accepted

✓ Paypal Payments Can Be Made To:
 info@wexclub.com

✓ Prices May Change Without Notice

✓ 10% Discount for 3 or more Items

SHIPPING CHARGES

United States

✓ Postal Book Rate { $4.00 First Item / 50¢ Each Additional Item

✓ POSTAL BOOK RATE Cannot Be Tracked!

✓ Priority Mail { $5.00 First Item / $2.00 Each Additional Item

✓ UPS { $6.00 First Item / $1.50 Each Additional Item

 NOTE: UPS Delivery Available to Mainland USA Only

Canada

✓ Postal Air Mail { $10.00 First Item / $2.50 Each Additional Item

✓ Personal Checks or Bank Drafts MUST BE
 US$ and Drawn on a US Bank

✓ Canadian Postal Money Orders OK

✓ Payment MUST BE US$

All Other Countries

✓ Sorry, No Surface Delivery!

✓ Postal Air Mail { $16.00 First Item / $6.00 Each Additional Item

✓ Checks and Money Orders MUST BE US$
 and Drawn on a US Bank or branch.

✓ Paypal Payments Can Be Made in US$ To:
 info@wexclub.com

SPECIAL NOTES

✓ RETAILERS: Standard Discounts Available

✓ BACKORDERS: We Backorder all Out-of-
 Stock Items Unless Otherwise Requested

✓ PRO FORMA INVOICES: Available on Request

ORDER ONLINE AT: www.adventuresunlimitedpress.com

Please check: ✓

☐ This is my first order	☐ I have ordered before

Name

Address

City

State/Province		Postal Code

Country

Phone day Evening

Fax Email

Item Code	Item Description	Qty	Total

Please check: ✓

	Subtotal ▶
	Less Discount-10% for 3 or more items ▶
☐ Postal-Surface	Balance ▶
☐ Postal-Air Mail (Priority in USA)	Illinois Residents 6.25% Sales Tax ▶
	Previous Credit ▶
☐ UPS	Shipping ▶
(Mainland USA only)	Total (check/MO in USD$ only) ▶

☐ Visa/MasterCard/Discover/American Express

Card Number

Expiration Date

10% Discount When You Order 3 or More Items!